Somerville
Through Time

LINDA J. BARTH, ROBERT H. BARTH,
JAMES L. SOMMERVILLE III

Dedications

LJB:
To the people of Somerville, the best town and the heart of the Crossroads of the American Revolution.

RHB:
To the memory of George Washington, who made Somerville his home during the Revolutionary War.

JLS:
To the residents of Somerville who are proud of its illustrious past and have an interest in learning more about the history and architecture of its fin de siècle highpoint.

America Through Time is an imprint of Fonthill Media LLC

Fonthill Media LLC
www.fonthillmedia.com
office@fonthillmedia.com

First published 2015

Copyright © Linda J. Barth, Robert H. Barth, James L. Sommerville III 2015

ISBN 978-1-63500-032-0

All rights reserved. No part of this publication may be reproduced, stored in a retrieval system or transmitted in any form or by any means, electronic, mechanical, photocopying, recording or otherwise, without prior permission in writing from Fonthill Media LLC

Typeset in Mrs Eaves XL Serif Narrow
Printed and bound by CPI Group (UK) Ltd, Croydon, CR0 4YY

Connect with us:
 www.twitter.com/usathroughtime
 www.facebook.com/AmericaThroughTime

America Through Time® is a registered trademark of Fonthill Media LLC

Introduction

The Borough of Somerville is a thriving county seat in the middle of Somerset County, New Jersey. It was settled in the 1700s by the Dutch and English. Dutch Reformed churches were established early and served by pastors, who were circuit riders. The Old Dutch Parsonage was home to these early domines as early as 1754.

A tavern was built at the junction of the Old York Road and the Easton Turnpike, the site of today's borough hall. The county courthouse was built on the green, after its predecessor in Millstone was burned by the Loyalist Queen's Rangers.

No one knows who gave the town its name, but it was known as Somerville by about 1800. Originally a sparsely populated farming community, the town grew rapidly after the arrival of the railroad in 1841. Early industry included brick making, a woolen mill, and a lace works.

During the American Revolution, George Washington and his aides lived in Somerville for six months (December 11, 1778, to June 3, 1779) during the Middlebrook Cantonment. The Continental Army was encamped throughout the area.

Although Somerville was settled in colonial times primarily by the Dutch who purchased land from the English proprietors of the colony, our "then" photos will focus mainly on the village in the late 1800s and early 1900s. The early village grew up around a church, courthouse, and a tavern built at a crossroads shortly after the American Revolution.

At the turn of the century, Somerville was a very contemporary community. Main Street was an avenue of commerce, lined with stores, services, and entertainment. Somerville was a stagecoach stop and, in 1900, the town boasted three newspapers, a thriving railroad station, a major shopping district and lots of entertainment. People traveled from neighboring hamlets and villages on the trolleys, and train service linked Somerville to New York, Trenton, Philadelphia, and more distant points. The municipality

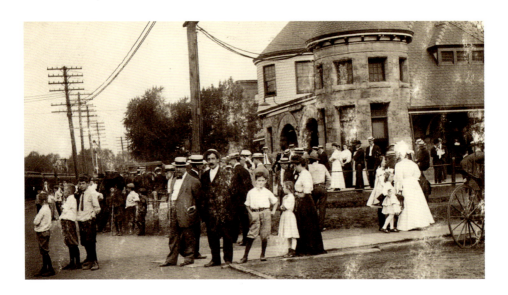

was part of Bridgewater Township until 1909, when Somerville formally separated from Bridgewater and became an independent borough. The town celebrated its Centennial in 2009.

While several neighborhoods feature distinctive Victorian architecture, other architectural periods are represented. National Register sites in the borough include the Daniel Robert Mansion, now the Borough Hall; the 1909 Somerville Court House; the colonial Wallace House, where George Washington spent a winter during the American Revolution; the Old Dutch Parsonage, home of the Reverend Jacob Hardenbergh, a founder and first president of Rutgers University, then called Queens College; the James Harper Smith Estate (privately owned); St. John's Episcopal Church and rectory; and the Fire Museum. Another register-eligible structure is the Victorian train station.

Originally the center of local commerce, the borough has evolved into a dining destination featuring over forty restaurants. Its location near major highways makes it an important hub in central New Jersey.

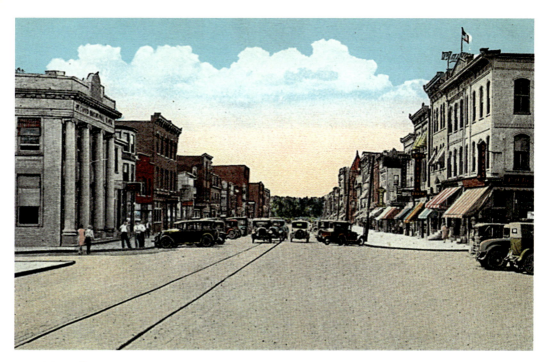

MAIN STREET: Somerville has always had a busy Main Street. From 1898 to 1933, the Public Service trolley ran down the street, connecting Plainfield with Raritan and, with a change in Bound Brook, to New Brunswick. Now, of course, the trolley tracks are long gone, and the parking is no longer diagonal to the curb on Main Street west of Bridge. This busy intersection with Bridge Street now requires a traffic light.

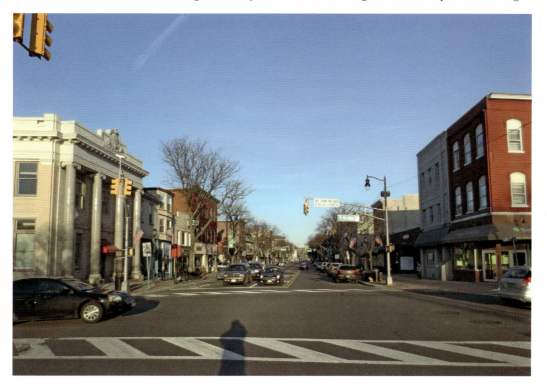

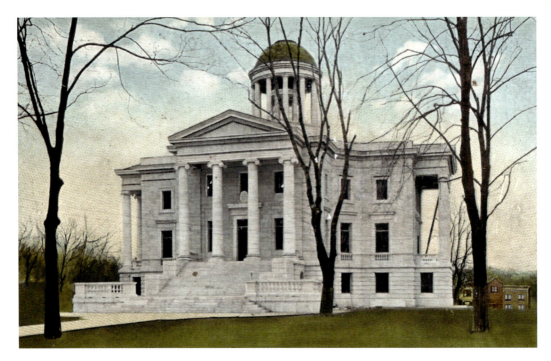

SOMERSET COUNTY COURTHOUSE: Perhaps the most impressive building on Main Street is the courthouse. Constructed in 1909 in the Beaux Arts Classicism style, the courthouse is topped by a gilded dome with a figure of Justice. The structure was designed by Gordon, Tracy and Swartout. James Reilly Gordon also designed the Arizona State Capitol. Swartout and Tracy designed the Missouri State Capitol. The Court House Green, now on the National Register of Historic Places, features three structures: the Courthouse, the First Reformed Church, and the Lord Memorial Fountain. The pre-1909 courthouse is shown in the inset.

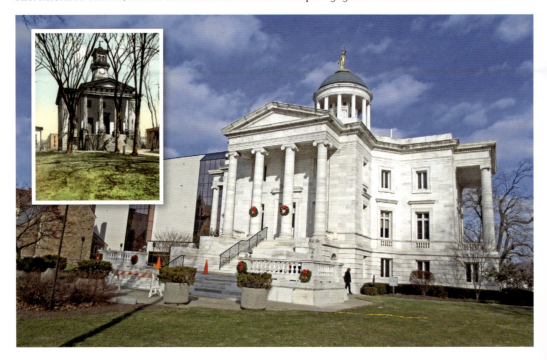

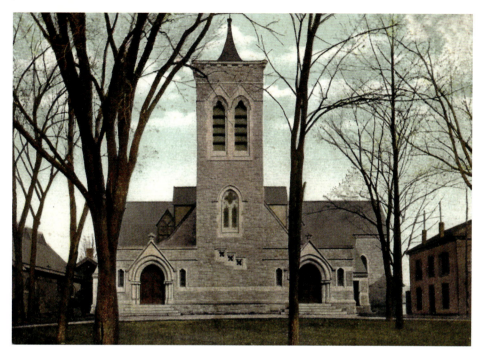

FIRST REFORMED CHURCH: This church is a free interpretation of the English Gothic style. Constructed in 1897, it is distinguished by its stained glass windows, with several by Tiffany. The architect, William Appleton Potter, is renowned for his work on the Princeton University campus. The church is now used by the county as the jurors' assembly room. In the modern view, the new courthouse with its glass panels rises behind the church.

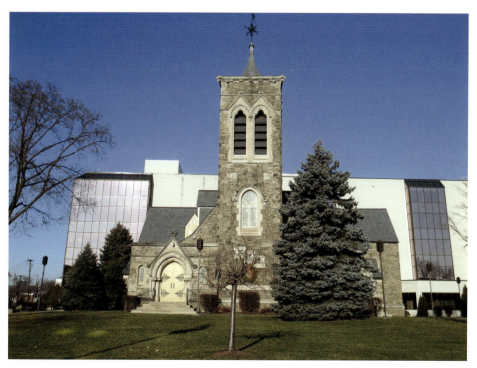

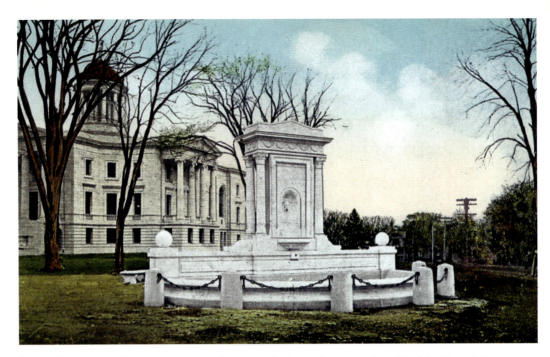

LORD MEMORIAL FOUNTAIN: Erected in 1910, the fountain was designed by John Russell Pope, architect of the Jefferson Memorial. It was donated by Alliene Lord in memory of her brother, John Haynes Lord, who had been the president of the Second National Bank, a pillar of St. John's Episcopal Church, and founder of the Somerset County Society for the Prevention of Cruelty to Animals. It was this last for which his sister wanted people to remember him. She left money in her will for a town fountain at which man and beast might refresh themselves. The Lord Memorial Fountain stands to this day, a graceful landmark on the Courthouse Green.

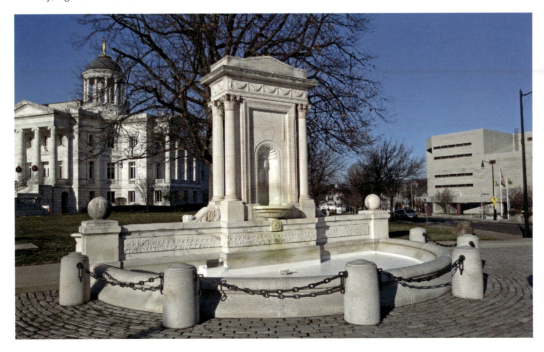

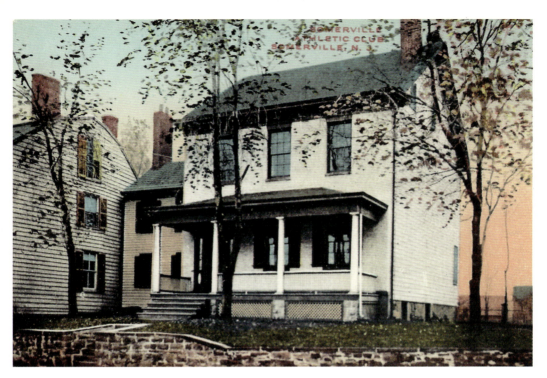

SOMERVILLE ATHLETIC ASSOCIATION: On the south side of Main Street, just east of the intersection with Grove, stood the Somerville Athletic Association. The complex, seen in the 1917 Sanborn map, included a clubhouse and a bowling alley. It is thought that Governor Peter Vroom had his law office in the smaller building at one time. As of 2015, this site was slated for redevelopment.

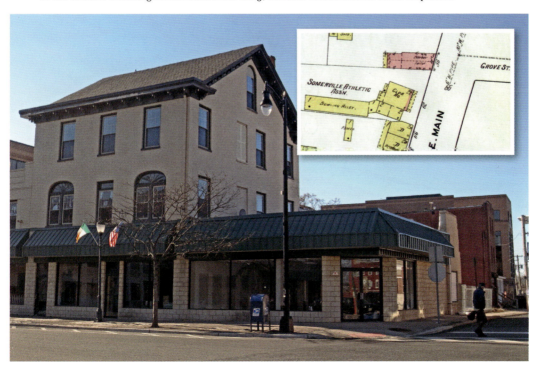

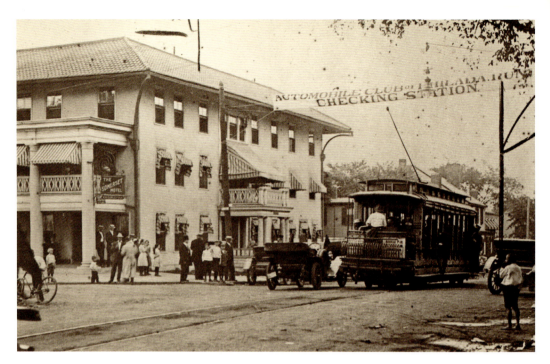

SOMERSET HOTEL: The hotel was built on the site of Tunison's Tavern (*c.* 1764), once the center of community meetings and a stagecoach stop. Tunison's eventually became the Fritts Hotel, whose two-story wing had been the original tavern. With the construction of the courthouse in 1909, new owners demolished much of the Fritts Hotel. Remodeled in the Colonial Spanish style, it offered first-class accommodations. In 2015 the hotel's restaurant, McCormick's, has closed, but the bar still offers light refreshment.

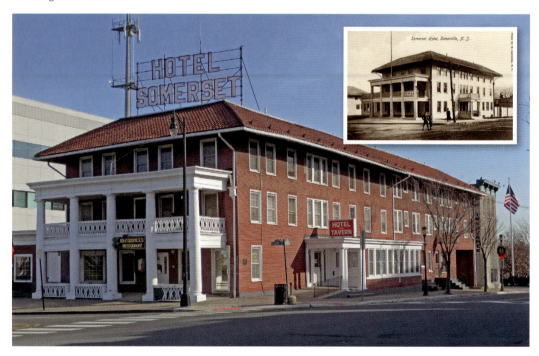

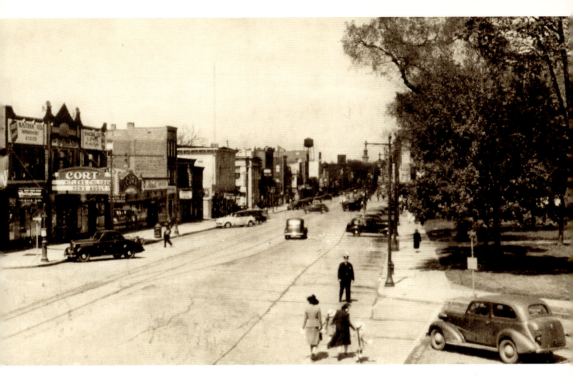

COURTHOUSE BLOCK: Taken from the balcony of the Somerset Hotel, this longer view of East Main Street highlights the marquee of the Cort Theatre as well as the diagonal parking that still exists on that block. To the right, the trees border the property of the Somerset County Courthouse. The Lord Memorial Fountain is just out of sight at the corner. Of course, the trolley tracks are now gone.

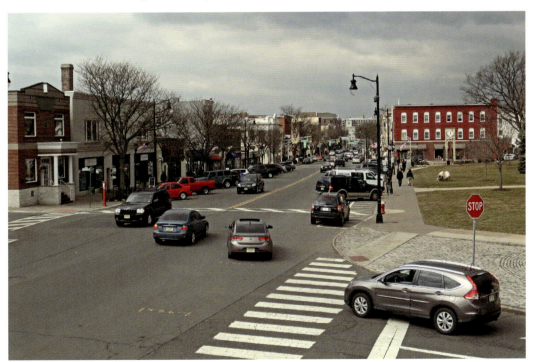

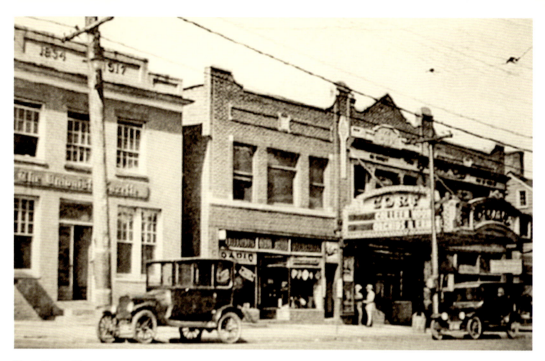

THE CORT THEATRE: Opened in October 1922, the Cort featured a Hope-Jones orchestral organ and a 1450-seat auditorium with leather seats. The gold fiber screen was restful to the eyes, but showed the films with clarity and brilliance. To build the theater, the developer demolished the 1801 Van Derveer house. The first film shown was "If You Believe It, It's So," and the last movie in 1983 was "D.C. Cab," with Mr. T. On the left, the former home of the *Unionist-Gazette* newspaper houses offices, including that of State Sen. Christopher Bateman.

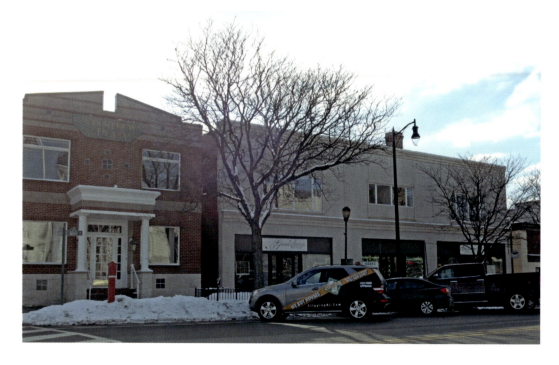

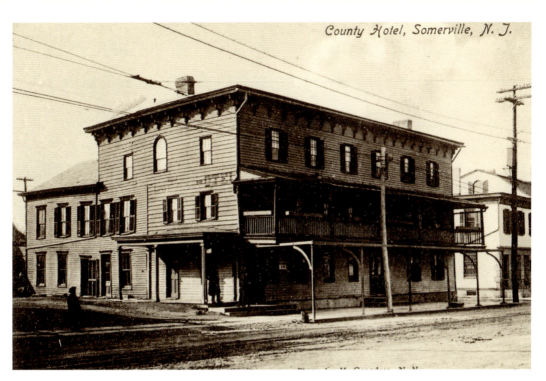

HOTEL: The County Hotel stood at the southeast corner of Bridge and Main streets. Its location across from the courthouse probably attracted clients from the legal profession. The view today shows the Sunrise Luncheonette and Minuteman Press. The Second National Bank, now Wells Fargo, can be seen on the right in both views.

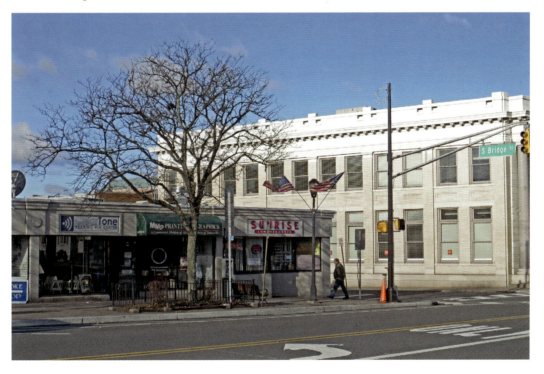

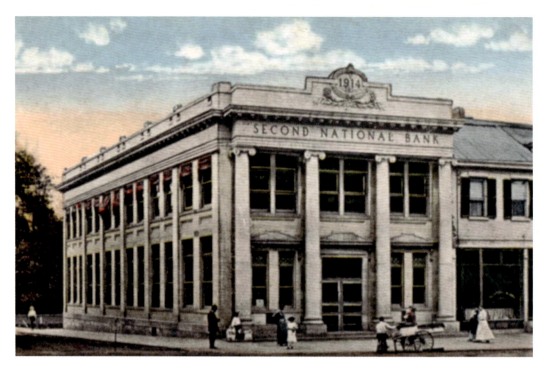

SECOND NATIONAL BANK: Built in 1914, as the date at the top attests, the Second National Bank was designed by Jay Van Nuys in the Beaux Arts style, with four Ionic columns and terra-cotta decoration. Although the building appears to be rectangular, it is actually wider at the rear than at the front, because the intersection is not a 90° angle. The first bank at this location (inset) was moved to 23 South Bridge Street, but is no longer there.

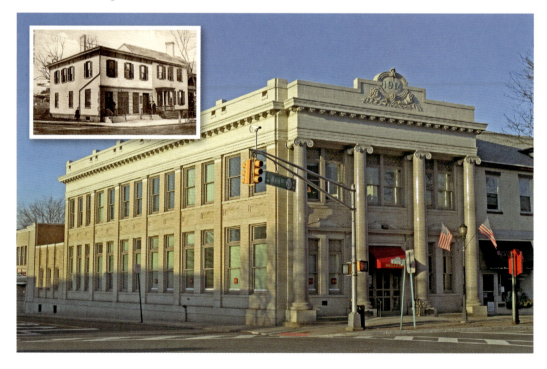

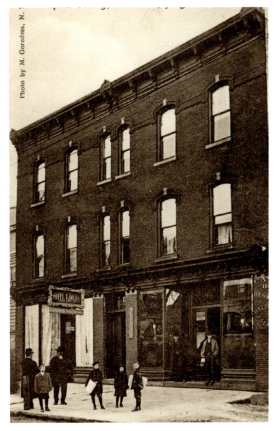

CAWLEY HOTEL AND RESTAURANT: The Cawley Hotel at 13-17 West Main boasted three restaurants. In 2015 the site is occupied by Tessuto Menswear, Carousel of Flowers, and Gimmee Gimmee Tees.

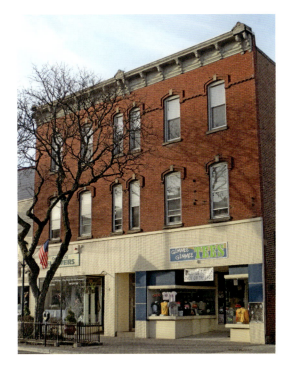

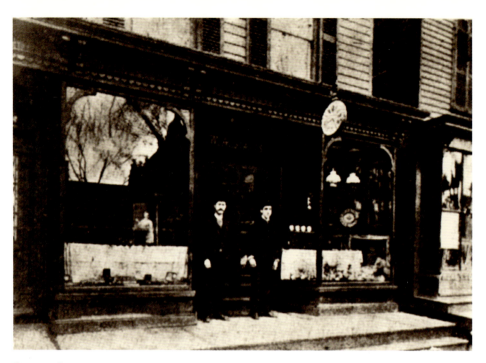

STAATS JEWELER: W. A. Staats Jewelers stood at 31 West Main Street. Above the storefront is a home, probably belonging to the family. Since September 2012, Front and Center, the retail store of the Center School, occupied this site as part of its work-readiness transition program for 18-21-year-olds. The Center School, a private, nonprofit, state-accredited facility for bright, learning-disabled students in Warren Township, was founded in 1971 by a small group of concerned parents and educators. In 2015 Marlenny's also occupies this site.

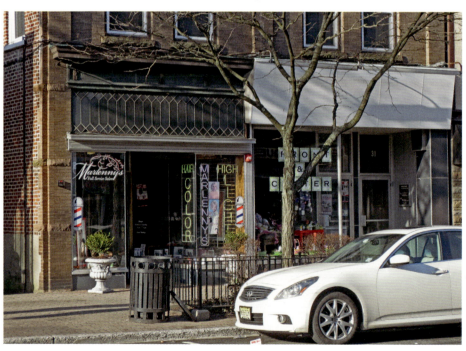

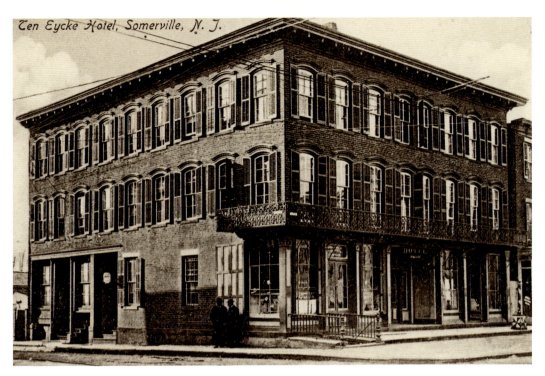

TEN EYCK HOTEL: After the railroad came to Somerville in 1841, several hotels were built. Here at the southwest corner of Division and Main stood the Ten Eyck Hotel. The hotel was replaced by a two-story building (below), which features glazed terra-cotta with shielded pediments. In 2015 it housed the Armed Forces Career Center. One block south and closer to the station was the Commercial Hotel.

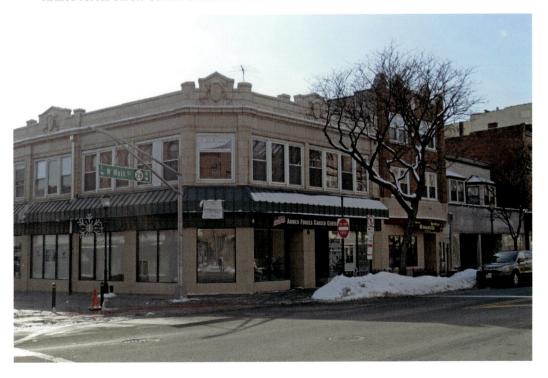

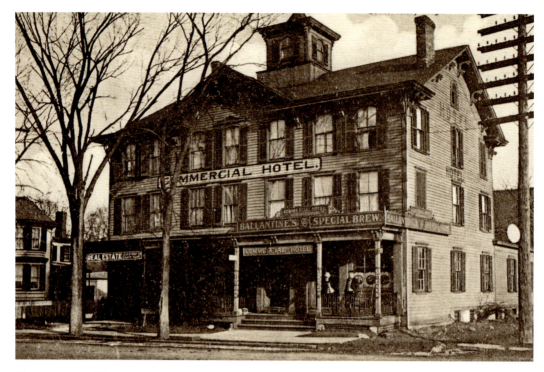

COMMERCIAL HOTEL: This hotel stood at the end of Division Street, between the railroad station and the coal pockets, just south of today's post office. In the black-and-white photo, the hotel can be seen east of the station. The Commercial (called the Astor from 1948-1971) was demolished to make way for urban renewal in the 1970s.

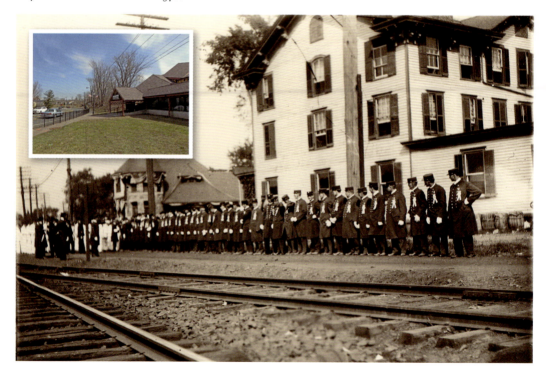

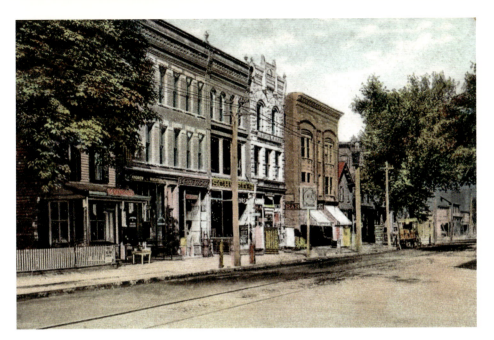

MAIN STREET: On the south side of the street, between Division and Union, were a number of shops, including Schwed's Clothier and Tailors and the Andrew Wachter meat market, known for its homemade sausage. The Thomas building with the white embellished cornice remains today in the photo below and houses Café Picasso. The house on the far left, above, is gone now. In that location is the Vincent Giardina Pedestrian Walkway, enabling shoppers to reach Main Street from the parking lot behind the stores.

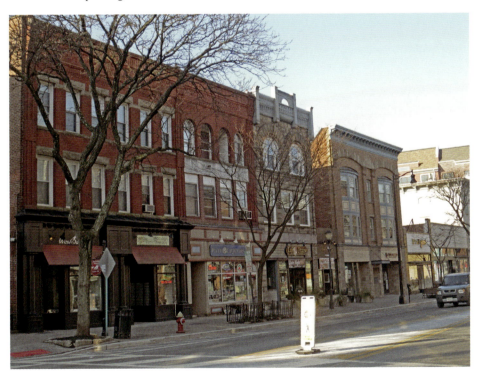

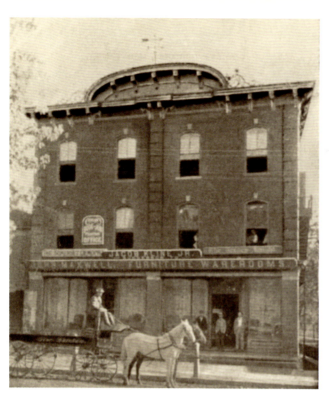

SOMERSET HALL/ALFONSO'S RESTAURANT: Built in 1882, this three-story building has a detailed cornice and brackets at the top. Somerset Hall, on the third floor, above the furniture store, had a large public area. Here was the second public performance by Ruth St. Denis (above), an innovator of contemporary dance. (Ruthie Dennis had performed earlier at the Adamsville School.) The hall offered many types of entertainment and was the largest public meeting space in the borough. A pool hall occupied the second floor of the Kline (later Schwartz) furniture store. Alfonso's Family Trattoria and Gourmet Pizza has occupied the space since 1978.

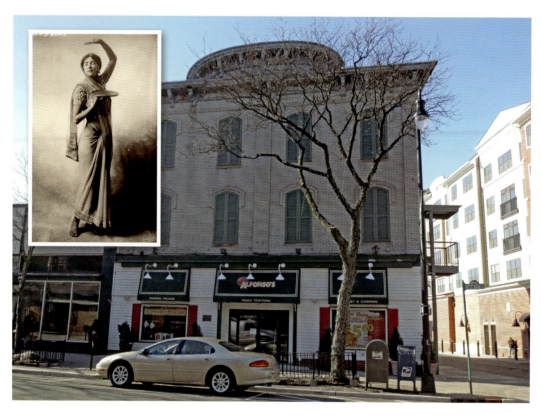

REGENT THEATRE: Opened in the early 1900s, the Regent began as an opera house and later was a movie theatre entertaining residents with silent movies and vaudeville acts. It stood on Main Street, near Doughty. According to former resident Gilbert Elliot Smith, Jr. (Somerville High School Class of 1932), the Regent had a big crack in the front where kids could look through and see the movies for free. For about 40 years, beginning in 1970, this building was the home of Brooks Uneeda Appliance, now located in Raritan. In 2015 the Melting Pot fondue restaurant occupies this space.

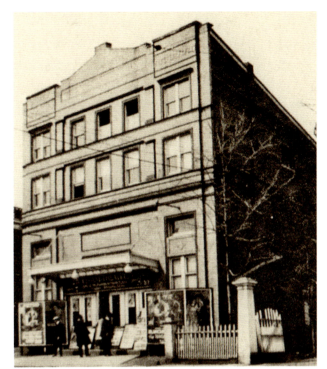

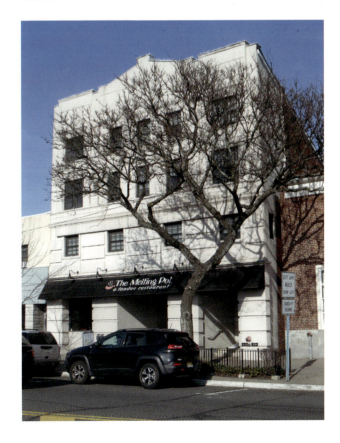

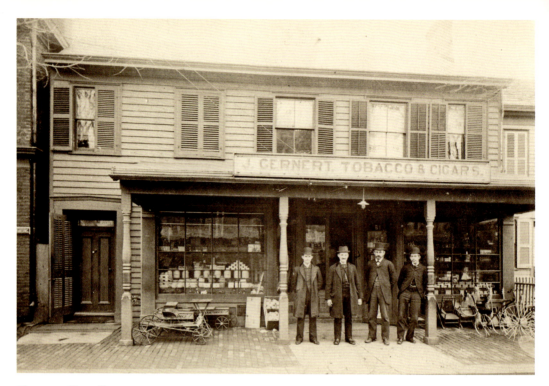

GERNERT DRY GOODS: At 146 West Main, the Gernert Brothers sold tobacco and cigars, among other products, including bicycles and rocking chairs. As the years went on, they installed a fancier sign and added books, toys, and many other items to their sales inventory.

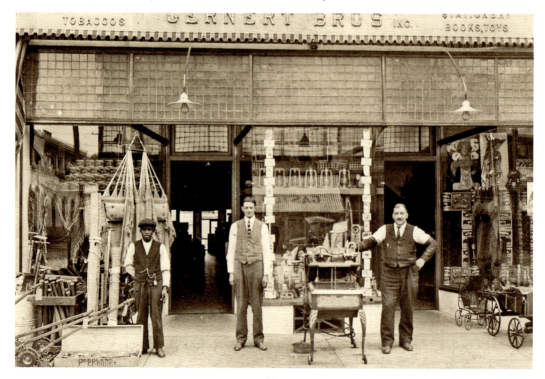

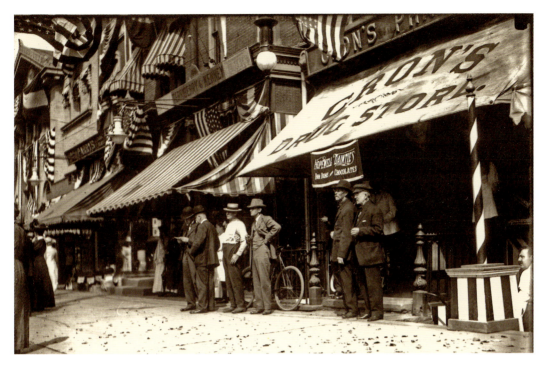

CRON'S DRUG STORE: Located at 92-96 West Main, Cron's Drug Store is decked out in bunting, most likely for the 1919 parade welcoming home the soldiers who fought in World War I. The sign hanging from the awning advertises "Hopewell Dainties, Bon Bons and Chocolates." Nearby shops are Parris and Terriberry & Kenney, dry goods, 1899–1924. In 2015 the Hungry Hound and Tropiano's Jewelers occupied these storefronts.

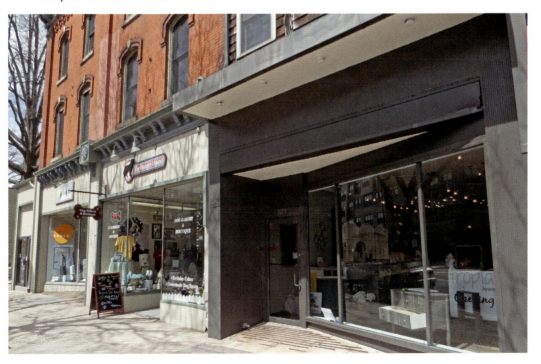

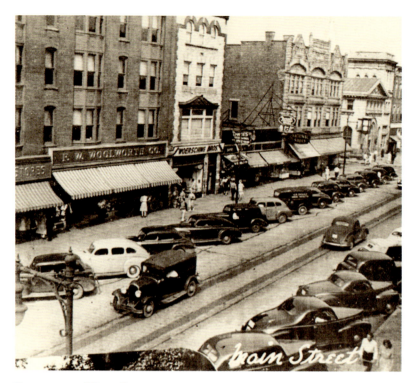

PARKING ON MAIN STREET: Unlike today, cars parked diagonally on both sides of the street. The Woolworth Five and Dime was a mainstay of downtown. It seemed as though anything you needed could be found at Woolworth's, including a sandwich at the lunch counter. For many years it was here, between Maple and Davenport streets. The Fishman Department Store is to the left of Woolworth's. To the right you can see Woersching Bros. hardware and Daniel's Dress Shop. In the late 1960s Woolworth's moved east of Maple, where the Somerville Antique Center is today.

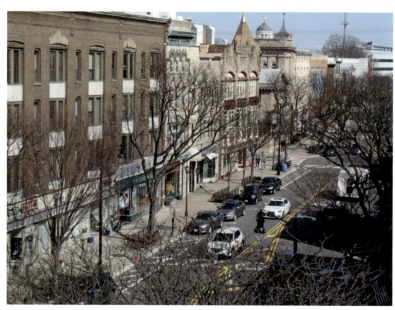

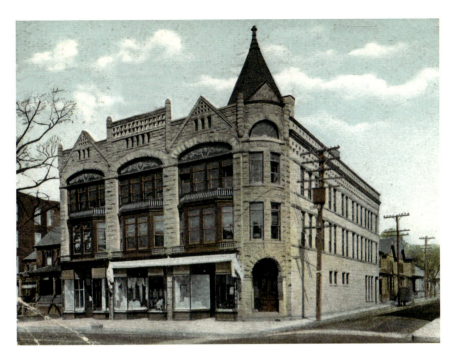

THE GASTON BUILDING: In 1891 Senator Lewis Thompson built this Romanesque brownstone at the corner of Main and Maple. Note its segmental arches, swags, faces, bays, and rounded tower. The words on the awning say, "J. G. Gaston Co., Dry Goods and Millinery," and it is this store that gave the building its name. The Somerville Post Office occupied the other storefront. The arched doorway led to the upstairs offices. Restored between 1995 and 2002 by Crem Builders, the building won the Somerset County Historic Preservation Award. The delicate metal faces in the frieze had been covered by paint and were lovingly scraped by hand.

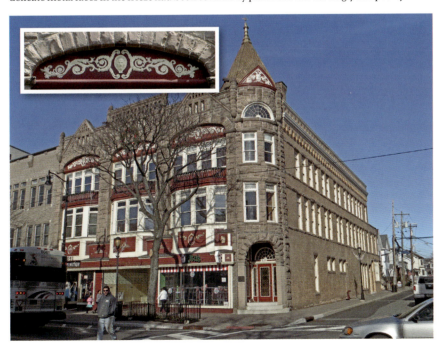

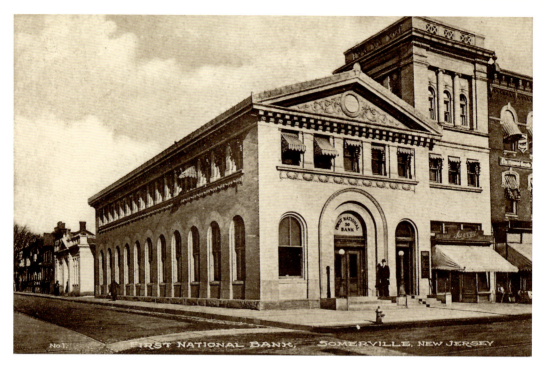

First National Bank/TD Bank: Situated on Main Street at the corner of Maple was the First National Bank, site of today's TD Bank. In this older view, the famous clock has not yet been installed. In the current view the clock is covered and no longer working. The bank was built in 1900 in the Beaux Arts style and designed by the atelier of George Post, architect of the New York Stock Exchange. The temple front of the bank has a pediment and terra-cotta swags and ornamentation.

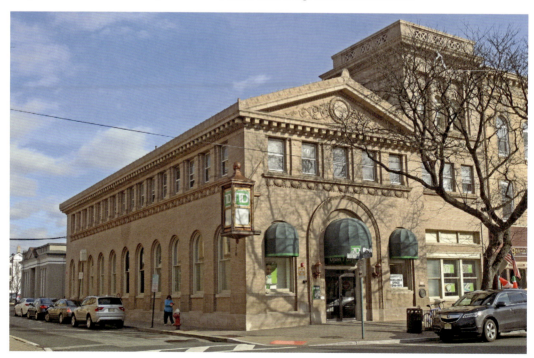

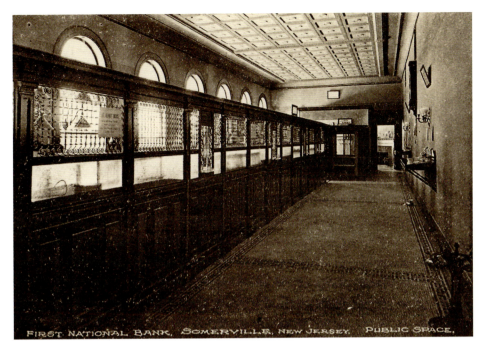

FIRST NATIONAL BANK/TD BANK: As the caption shows, this view from the front door looking toward the back is the public space. The wall behind which the tellers work is no longer there, as you can see in the modern picture. The lovely arched windows, however, still grace the west side of this historic Beaux Arts building. The authors thank the TD bank for allowing us to take the matching image.

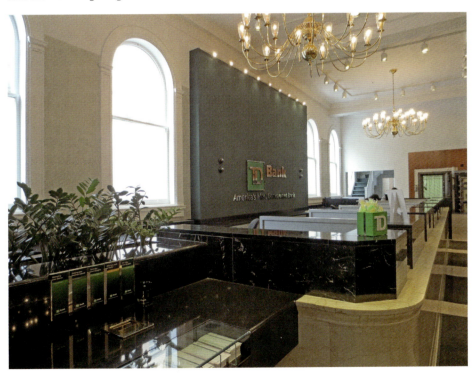

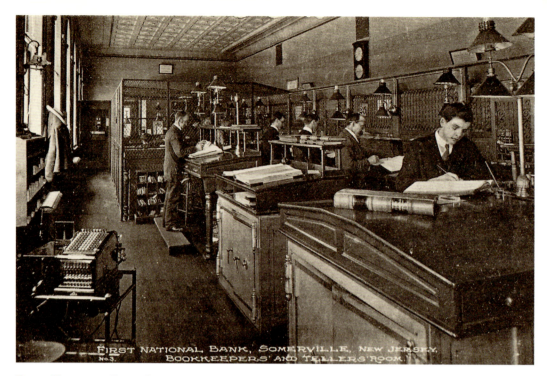

FIRST NATIONAL BANK INTERIOR: Surprisingly, these two views of the bank interior were sold as postcards. Nowadays, photos of the private rooms of a bank are not allowed, but it's interesting to note the huge desks of the tellers and their location, perpendicular to the teller windows. Below we see the conference room where the bank directors met.

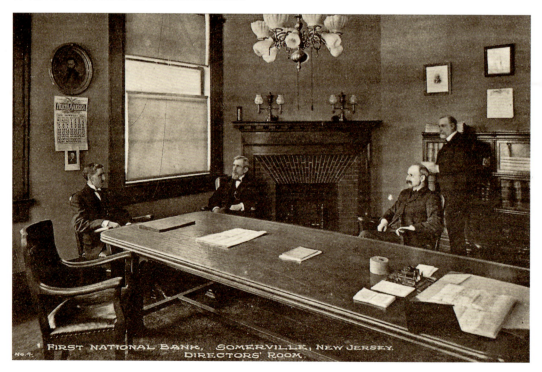

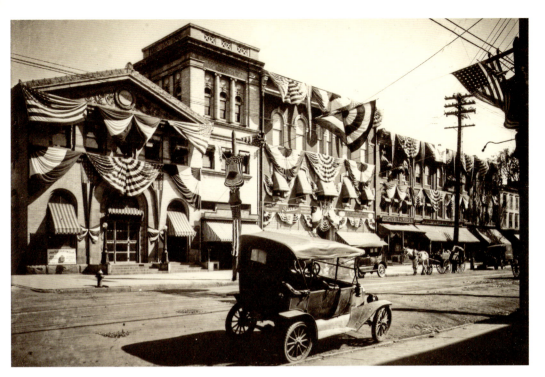

TIME FOR A PARADE: Decked out for a parade, the First National Bank, Association Hall (with the *Unionist-Gazette* offices), and adjacent stores display patriotic bunting. This may have been the 1919 parade that welcomed the soldiers home from World War I. Note that horses and carriages still compete with automobiles on Main Street.

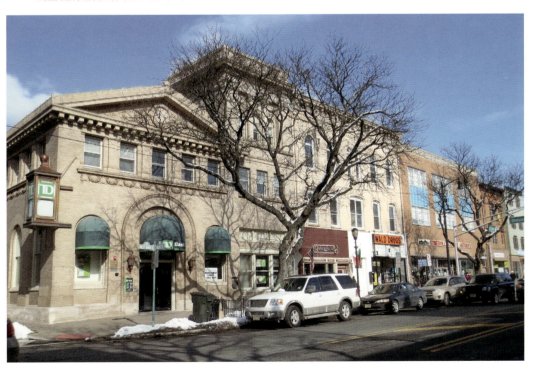

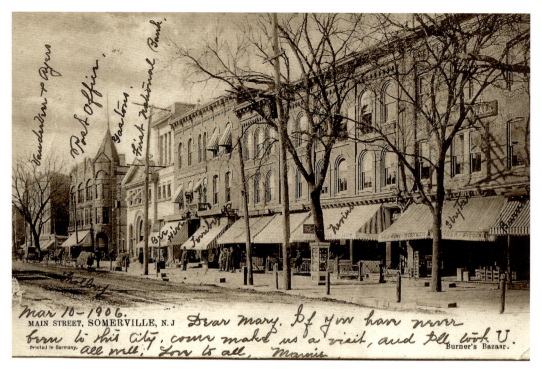

MAIN STREET BETWEEN NORTH BRIDGE AND MAPLE: In this similar view, the postcard sender has kindly labeled some of the businesses. To the west is Washington & Ayers and Gaston's, and to the east the First National Bank. The message says, "Dear Mary, if you have never been to the city, come make us a visit, and _____. All well. Love to all, Marnie."

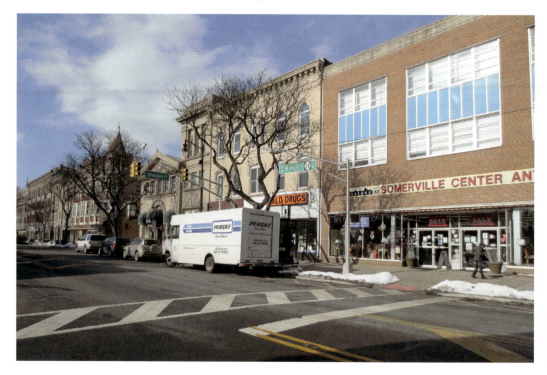

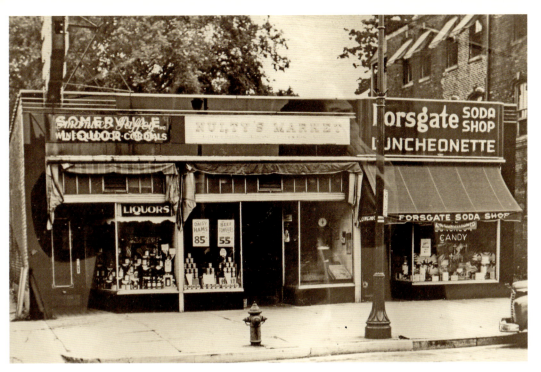

NULTY'S MARKET/PHOENIX CAFÉ: In 1935, Fred Sisser bought the building at this location, tore it down, and built the current structure, 24-26 West Main Street. Somerville Liquors, Nulty's Market, and the Forsgate Luncheonette were here for many years. Later a farmer's market replaced the liquor store. In 1993 New Start Consignments opened. Phoenix Café, which began in 2000, serves breakfast and lunch every day.

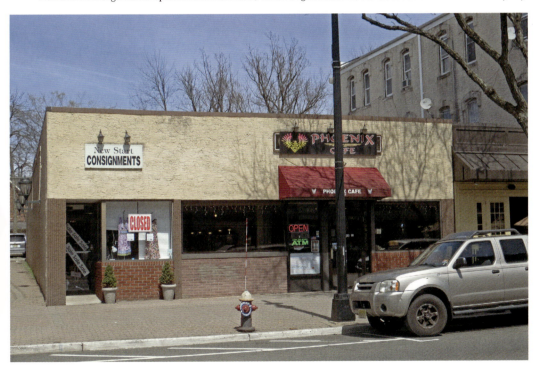

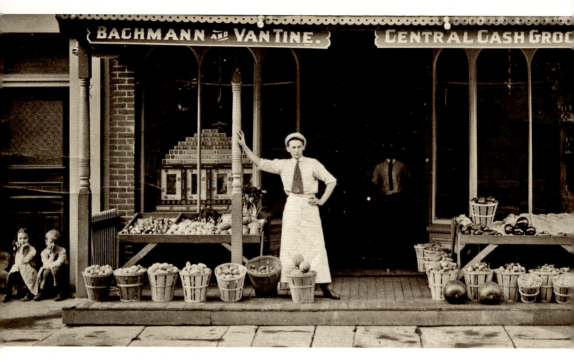

BACHMANN AND VAN TINE/SAVOR: Located at 18 West Main Street, Bachmann and Van Tine operated a cash grocery, one of several in town. As the shopkeeper awaits customers, three youngsters sit with their heads on their hands, watching the world go by. In 2015 the Savor restaurant occupied this space.

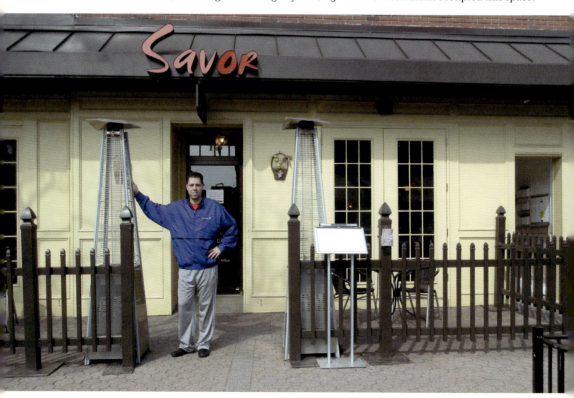

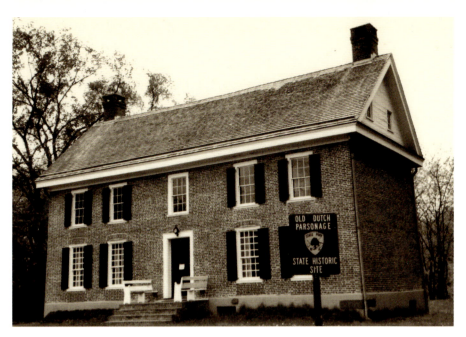

OLD DUTCH PARSONAGE/DOUGHTY HOUSE: Built by the Rev. John Frelinghuysen in 1751, the parsonage was the home of the Rev. Dr. Jacob Hardenbergh during the Revolution. He served three area Dutch Reformed churches. When owned by Joshua Doughty, the house was located near the tracks of the Central Railroad of New Jersey, at the foot of Doughty Street. When the railroad threatened the building in 1907, the Frelinghuysen family arranged for it to be moved to its current location on Washington Place, where it was used as the headquarters of the Daughters of the American Revolution. Deeded it to the state in 1947, it is now a state historic site, open to the public for guided tours Wednesday through Sunday.

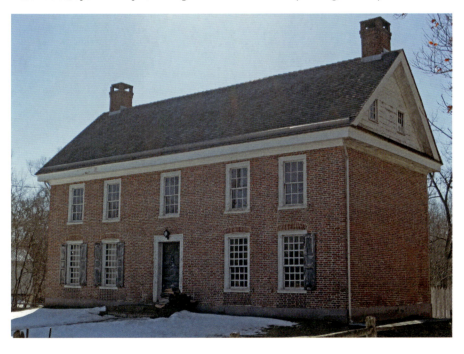

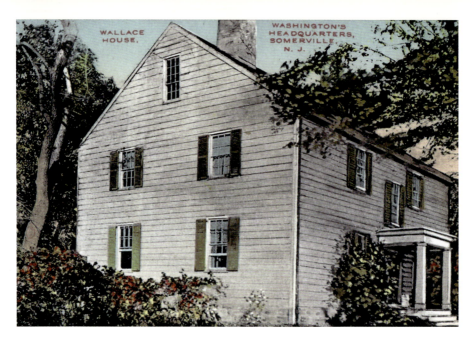

WALLACE HOUSE: In 1778 John Wallace moved here from Philadelphia and built this home as a retreat from the war. That fall General George Washington, Martha, and his aides arrived and spent six months here. Washington oversaw the Middlebrook Cantonment and with his generals planned the Iroquois campaign, which was carried out by General Sullivan in 1779. The Revolutionary Memorial Society of New Jersey, formed in 1896, purchased the home and opened it as a museum. The society in turn deeded it to the state in 1947. The Wallace House is now a state historic site, open to the public for guided tours Wednesday through Sunday.

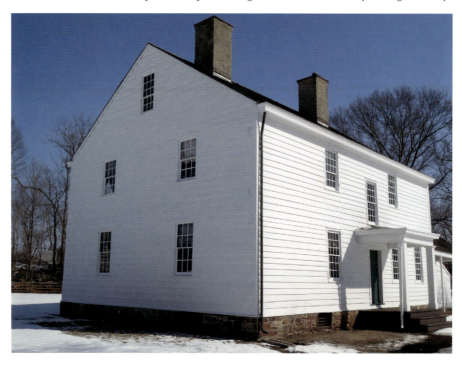

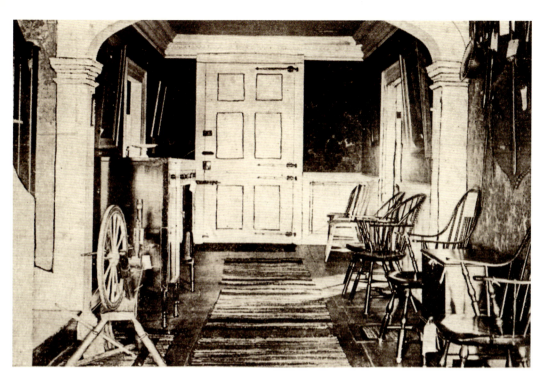

CENTER PASSAGE: Washington and his aides would have entered through this passage, in which the woodwork was painted white during the early 1900s. Extensive paint analysis revealed that the original color was burnt umber. In the early days as a museum, there was no collections policy, so all donations were accepted. Now, however, the Wallace House is furnished as a period home.

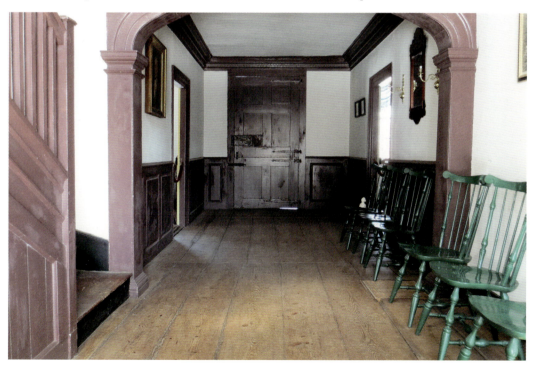

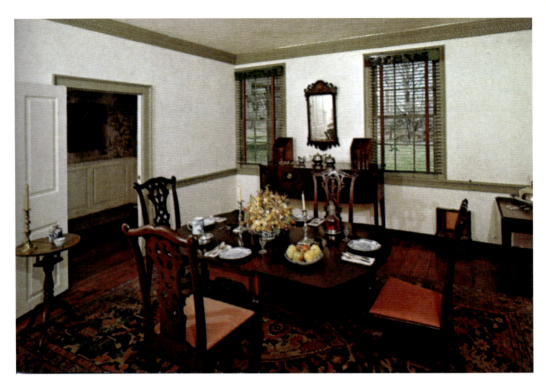

DINING ROOM: In the above view from the 1960s, work has begun to make the dining room into a correctly furnished period room, but the oriental carpet has not yet been removed. The floor (above), c. 1850, was nailed on top of the original boards, which have now been exposed (below).

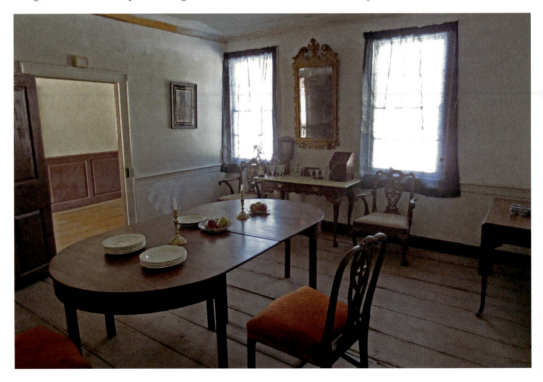

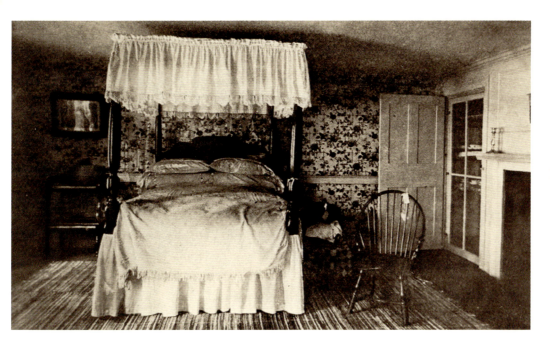

Northeast Bedchamber: The flowery wallpaper and Venetian carpet have been removed from Mrs. Wallace's bedchamber. The woodwork has been restored to its original blue color. In the early 1900s a glass door was placed in front of the closet, which was used as a display case. At that time the fireplace had been given a Colonial Revival appearance, with the inside painted black. That, too, has been restored to its original look.

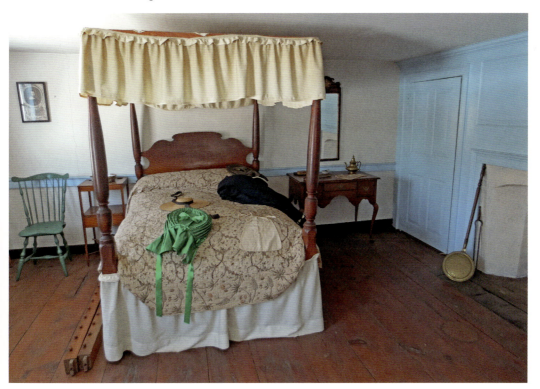

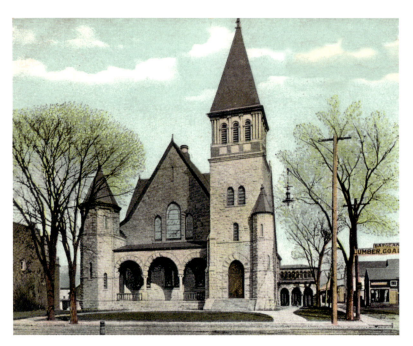

Second Reformed Church/United Reformed Church: In 1834, twenty-four members withdrew from the church on the Courthouse Green and organized the Second Reformed Church. Both churches continued to grow over the next 140 years. In 1974, the two churches were reunited in this Richardsonian Romanesque-style sanctuary built in 1893 at 100 West Main Street. The impressive oak pulpit given to the First Reformed Church by the Frelinghuysen family was installed in the Second Reformed Church as a memorial to Theodorus Jacobus Frelinghuysen, who had been the first pastor of both congregations.

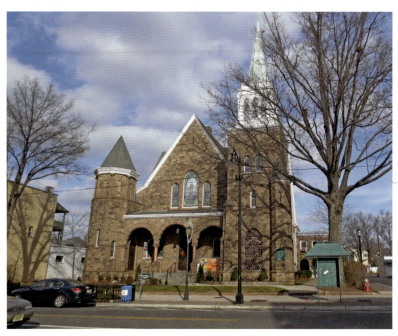

ST. THOMAS A.M.E. ZION CHURCH:
This African Methodist Episcopal Zion Church on Davenport Street, organized in 1858, is the town's oldest African-American congregation. The Rev. William Robeson left the Witherspoon Street Presbyterian Church in Princeton, accepted a pastorate in Westfield, and then came to this church in 1910, because he wanted his son to attend the integrated high school in Somerville. Paul Robeson, Jr. became a scholar athlete at Rutgers, an opera singer, and star of stage and film.

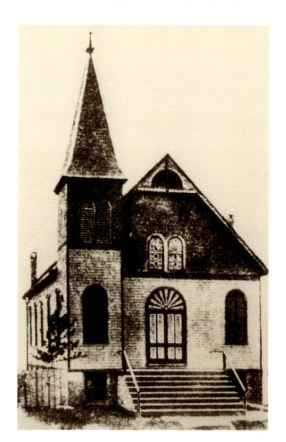

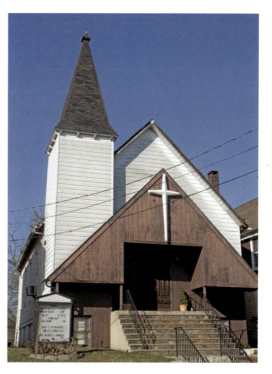

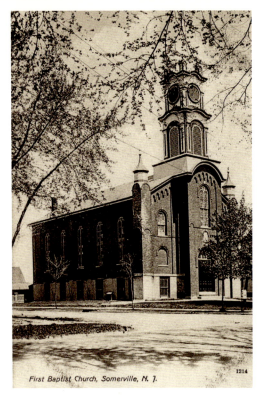

First Baptist Church, Somerville, N. J.

FIRST BAPTIST CHURCH: The First Baptist Church was organized in 1843. Baptisms were performed in the Raritan River or the Raritan Power Canal until 1856 when a baptismal pool was built under the platform in the meetinghouse on West Main Street. In 1873, when the congregation outgrew the facility, they built a new church on High Street, with a clock and bell installed in the tower, as seen in the older photo. In 1926 a fire badly damaged the clock, the spire, and much of the church, and the organ fell into the basement. Within two years the sanctuary was rebuilt, and in 1983 a facelift completely changed its appearance.

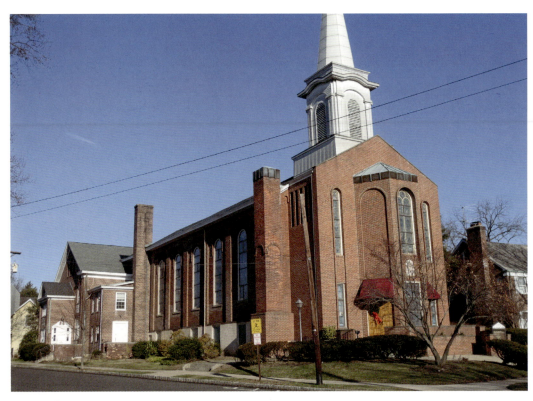

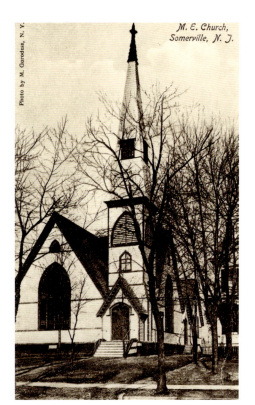

UNITED METHODIST CHURCH: This church began in 1832 in a wooden building on South Bridge Street. Two adjacent lots were purchased, one for the parsonage, which still stands at 30 South Bridge (inset). In 1879 the congregation built a Gothic-style church on West High. In 1922 philanthropist James B. Duke donated $80,000 toward a new church. Two years later, the Somerville and Raritan Methodist Episcopal congregations joined, the latter donating the money from the sale of its church to help fund the new sanctuary. The new church was built in the English Renaissance style, following the Wesleyan tradition, and was dedicated in 1929.

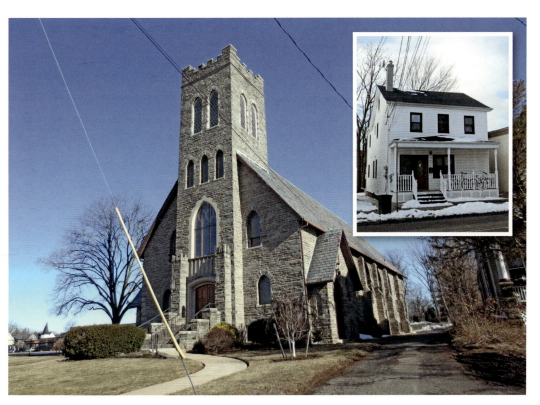

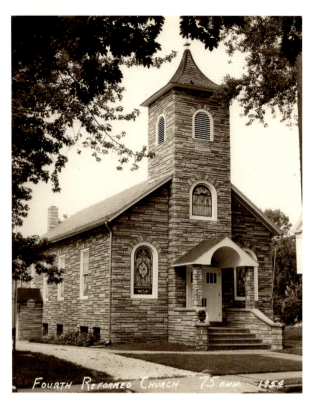

FOURTH REFORMED CHURCH/ SPANISH SEVENTH-DAY ADVENTIST: Begun in 1879, the Fourth Reformed Church originally served a German-speaking congregation. Meetings were first held in the old courthouse and later in the home of Mr. Doughty. The Cornells then donated the property on Middaugh Street, with the stipulation that Protestant services must always be held there. Within five years, the present building was constructed. A tower was added in 1899. Today the building houses a Spanish Seventh-day Adventist Church.

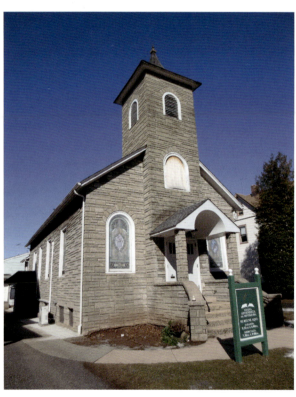

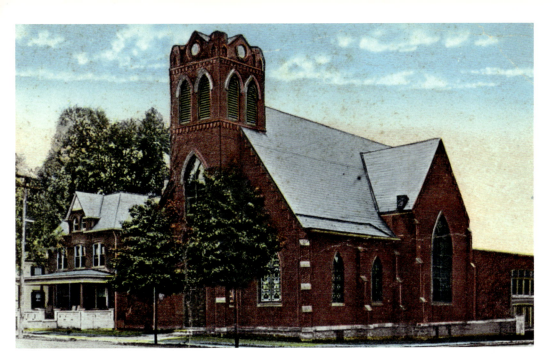

IMMACULATE CONCEPTION R.C. CHURCH: The first Catholic parish in Somerville, the Church of the Immaculate Conception, was organized in 1883. Opened in 1888, this small brick church on West High at Davenport was destroyed by fire in 1965. On the morning of January 6, 1965, Father Eugene Kelly had been the last person in the church as he celebrated the 7:30 Mass. He then returned to the new rectory on Mountain Avenue. He was stunned when a policeman said, "Father Kelly, your church is on fire!" The old rectory, to the left, still stands, but is now a medical office. The new church on Mountain Avenue was dedicated in 1975.

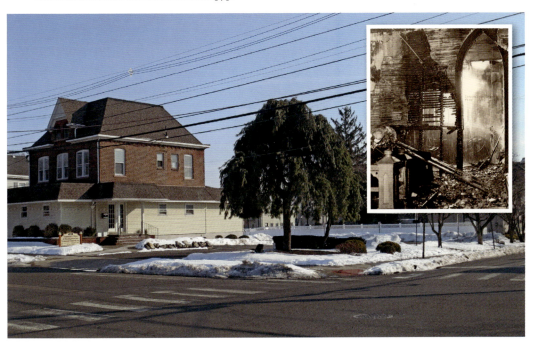

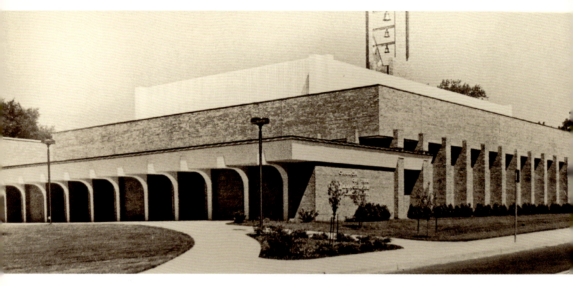

New Immaculate Conception R.C. Church: After the first church had burned, Mass was said at Immaculata High School. By 1970 property was purchased on Mountain Avenue for the new church. The first Mass was said in the new edifice on July 26, 1975.

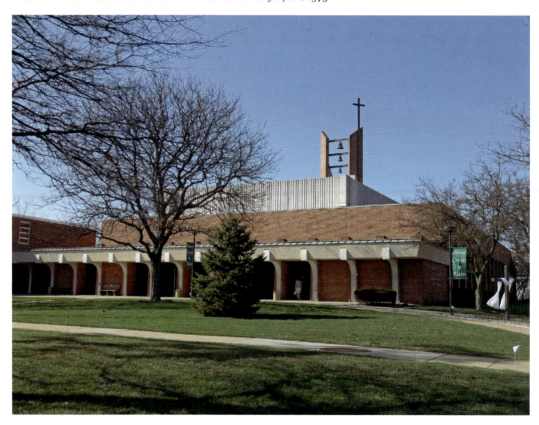

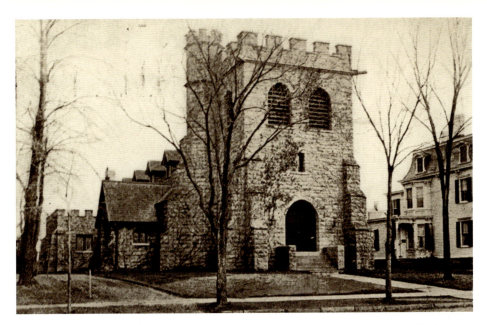

ST. JOHN'S EPISCOPAL CHURCH: Constructed in 1895 in the Early English Gothic Style, St. John's, which is on the National Register of Historic Places, contains several stained-glass windows by the Tiffany, Payne, and D'Ascenzo studios. The church was designed by Horace Trumbauer, architect of the Philadelphia Art Museum and the Duke University campus. The stone rectory, constructed in 1909, was designed to harmonize with the church. When parishioner Henry A. Smith died at the young age of 43, his father, J. Harper Smith, offered to build the rectory in his memory. Trumbauer, greatly admired for his design of the church, was hired as the architect for the rectory, built for $18,000.

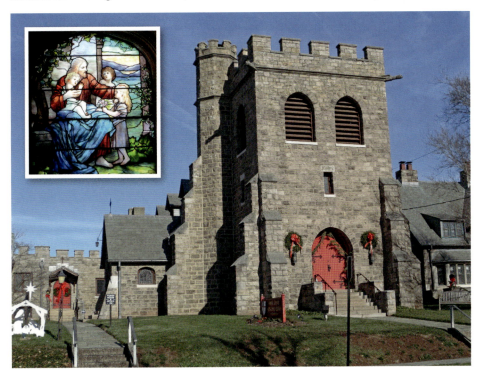

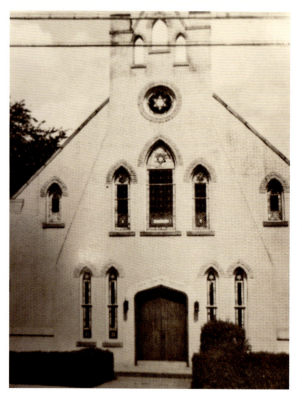

CONGREGATION ANSHE CHESED: In 1906 the Anshe Chesed Cemetery Association became Congregation Anshe Chesed. By 1911 they had built this synagogue and moved the Torah scroll to the new building. The congregation merged with Temple Beth Israel in 1970, creating Temple Sholom in Bridgewater. Today this structure serves the congregation of the Covenant Missionary Baptist Church, which was organized in 1979 in Bridgewater. It purchased this building, the former home of the Jewish Community Center.

Somerville had another Jewish congregation, Temple Beth-El, which began in 1953 on the third floor of 30 West Main Street. Needing more space, they bought #228 Altamont, the Harper Smith mansion. The congregation converted the three-story home and carriage house into a synagogue and school.

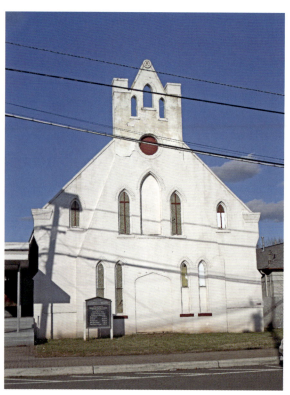

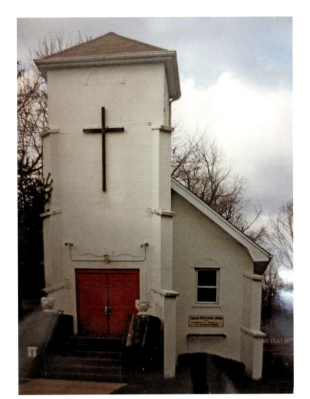

SHILOH PENTECOSTAL CHURCH: The Shiloh Pentecostal Church began in a little building that had been used for gambling, dancing, and pool; it had been closed with the stipulation that it could only be used as a house of prayer. In the 1940s, the congregation razed the old pool hall and broke ground for the new sanctuary on Davenport Street. They worshipped in the basement until the sanctuary was completed. In 2006 they began an expansion, as seen below.

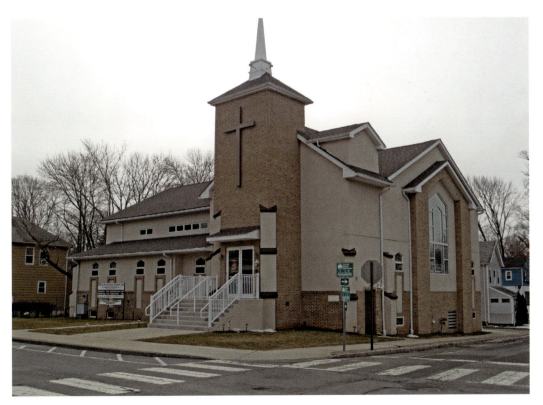

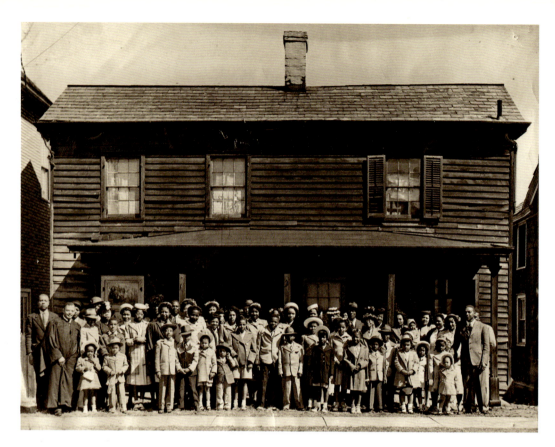

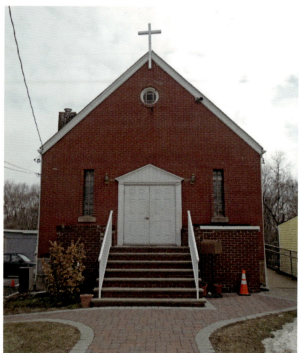

St. Paul Baptist Church:

In 1927 Rev. Joseph Aaron Lacy organized the mission as the St. Paul Baptist Church, with meetings held at 51 Hamilton Street. In 1931 the church purchased a house and a lot (present church site). In 1947, they broke ground for a new church building. A year later the basement was completed and used for worship purposes. On September 27, 1953 the new building was dedicated with new pews and furnishings and a Hammond organ. The cornerstone was laid on June 6, 1954 and a few months later the baptismal pool was installed.

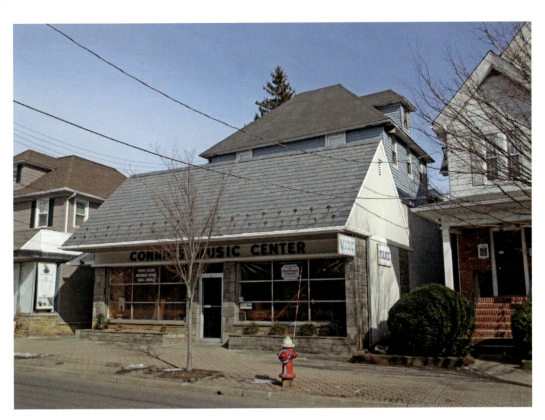

GOOD SHEPHERD LUTHERAN CHURCH: In 1952 the first Lutheran service in Somerville was held at the YMCA and within three months the Good Shepherd Lutheran Church had been chartered. As more members joined, the congregation moved to Connie's Music Center on Davenport Street. In 1957, the church dedicated its own house of worship on Union Avenue between North Clark and North Richards avenues.

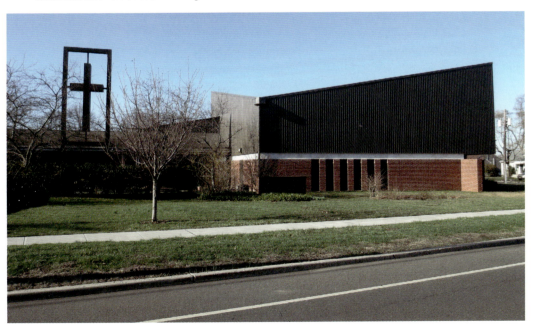

EMMANUEL REFORMED EPISCOPAL CHURCH: Organized in 1943, this church began in a storefront on Main Street. Then for fourteen years the congregation worshipped in the pastor's home at 318 East Main Street (above). In 1957, the present church on Grant Avenue was dedicated.

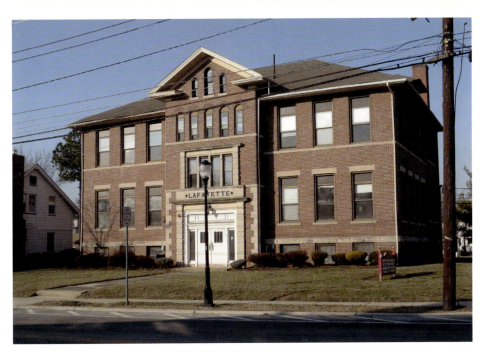

UNITARIAN UNIVERSALIST: Built in 1967 for the First Church of Christ, Scientist, this building at 123 East Cliff Street is now the home of the Unitarian Universalist Congregation of Somerset Hills (UUCSH). The congregation was founded in 1996 with the first service held in 1997 at Raritan Valley Community College. Office space was housed in the upstairs of the flower shop next to the Pluckemin Presbyterian Church from 1997 to 2000 and later moved to the basement of the Lafayette School (above). In 2010 UUCSH purchased the Christian Scientist church building and moved services and offices to the new location, where the first service was held September 12, 2010.

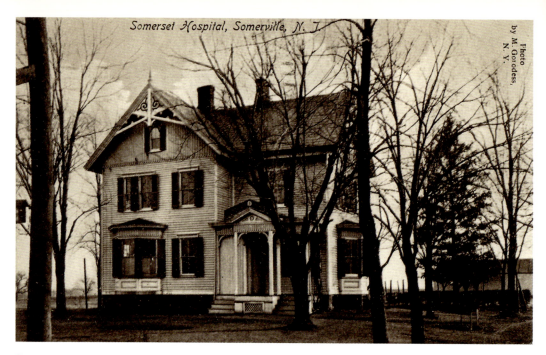

SOMERSET HOSPITAL: Dr. Mary Gaston graduated from the Women's Medical College of Philadelphia and opened her practice in 1889 in the family home on High Street. She encouraged the women of Somerville to establish an emergency hospital in 1894. When that became too much for volunteers, she and others began the Somerset Hospital in 1899 in the Lord Mansion on Main Street (above). After electricity and running water were installed, the hospital opened in 1901 with 10 doctors and 12 beds. Between 1911 and its closing in 1925, many additions were built until it reached its capacity of 24 beds. The building is now Chelsea House at 350 East Main Street.

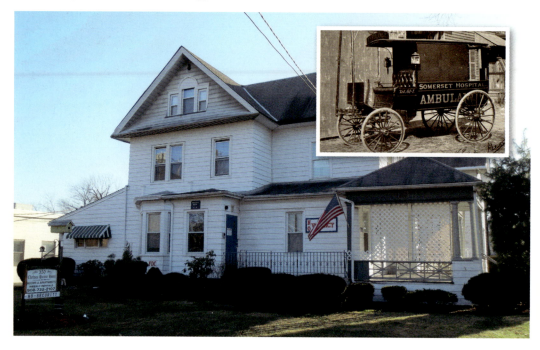

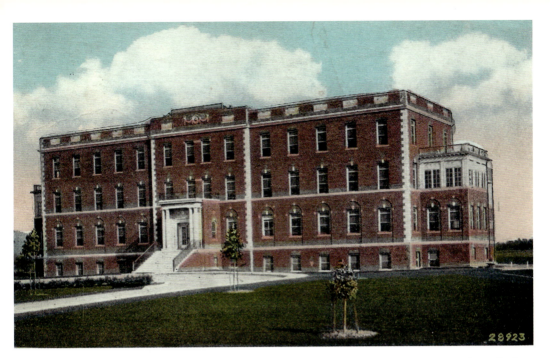

SOMERSET HOSPITAL: The new, brick hospital opened in 1925 on Rehill Avenue with 100 beds, a modern lab, a delivery room, men's and women's wards, a kitchen, and state-of-the-art operating rooms. The hospital, now the Robert Wood Johnson University Hospital-Somerset, has been so enlarged that it is difficult to find the original brick structure (in which one of the authors was born) among all of the thirty-two additions. But you can still see the white, rectangular vents at the very top.

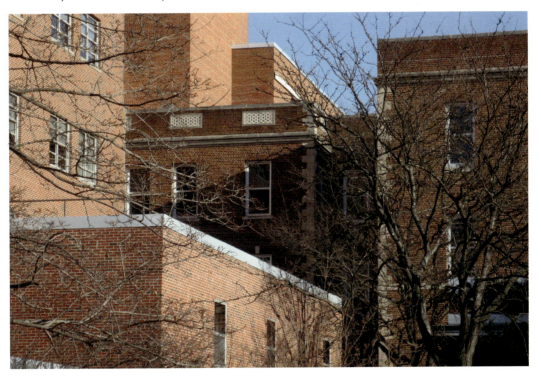

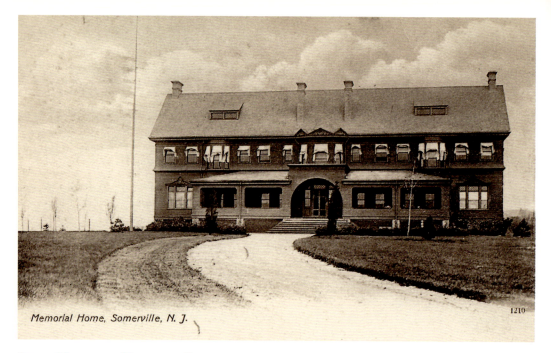

Memorial Home, Somerville, N. J.

DEATS MEMORIAL HOME FOR ORPHANS: In 1900 at the corner of North Bridge and what is now Route 22, an orphanage was built so that destitute children from New York could grow up in wholesome surroundings. The two-story frame structure, built with a $40,000 bequest from Hiram Deats of Flemington, had a long, shady verandah and a wide arched portico. The second-floor had dormitories for one hundred children, and the ground floor held a school and dining room. In the small, attached hospital, sick children and new arrivals could be kept until it was certain they did not carry contagious diseases. Despite good intentions, the Deats Memorial Home did not last two decades.

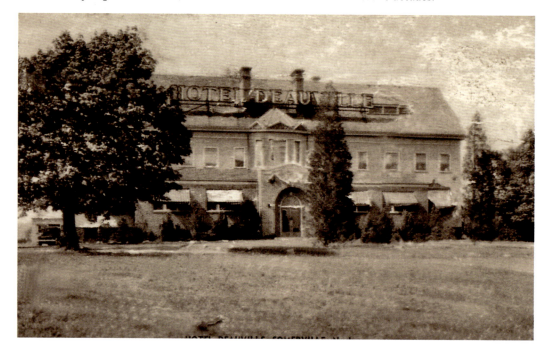

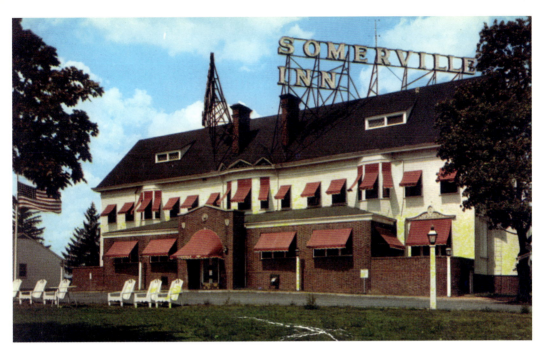

SOMERVILLE INN: The property was empty in 1917 when Company M troops encamped on the grounds before being shipped overseas. (A bronze plaque on the courthouse lawn commemorates their stay.) A new owner opened the home as the Hotel Deauville (previous page) in 1931, installing a red neon sign with letters six feet high out front. In 1940 it was bought by Mr. and Mrs. Leo Kauder and transformed into the Somerville Inn. The building burned in a spectacular fire in 1962. It was rebuilt and continued as a popular dining and dancing spot in the Raritan Valley, operating for forty years. The site of the Deats Home and the Somerville Inn is now a switching station for Public Service Electric and Gas.

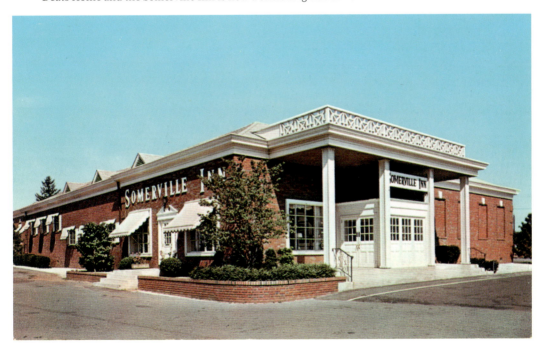

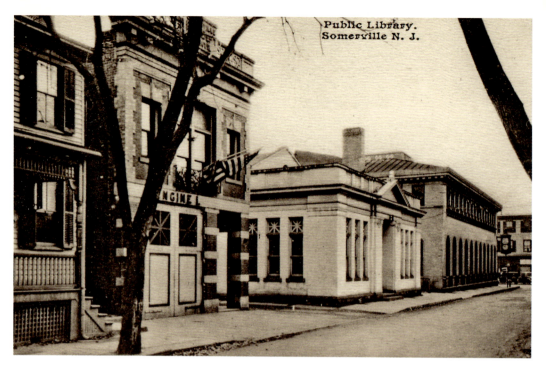

ENGINE COMPANY NO. 1: Organized in 1878 with 65 members, this oldest company in town used an Amoskaeg Steam Fire Engine, which was drawn by two horses and housed in a fire house on Maple Street (top photo, tall structure). This building was handsomely fitted with parlors and served until 1961 when the company moved to a new building on East Main Street. Upon completion of the West End High Street firehouse, the Maple Street structure was sold and demolished.

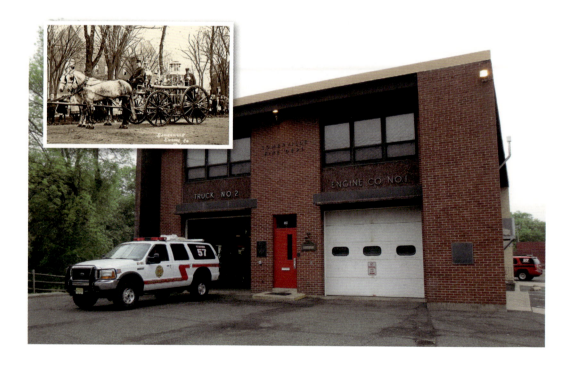

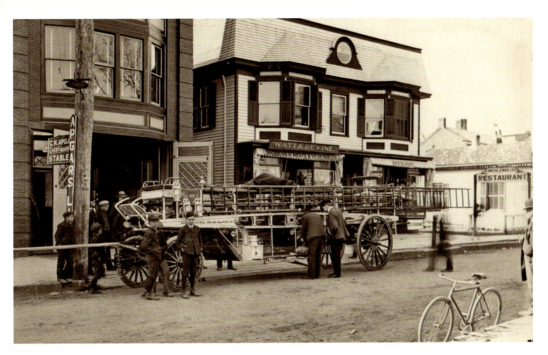

CENTRAL HOOK AND LADDER: In 1880, members of Engine Company #1 organized Central Hook & Ladder. The truck was housed in a small frame building on Union Street. In 1896 a movement was started to find larger quarters. Entertainment, minstrel shows, and card parties were held to raise funds, and land was purchased on Division Street. A three-story brick building was erected in 1902. To raise additional funds, the Hooks used their team and dump truck to collect garbage in town, charging 25 cents a week per customer. In 1984, the Hooks accepted delivery of a new 100-foot Seagrave aerial, still in service today. In 2015 Carol's Creative Chocolatez occupies this spot at 24 Division Street.

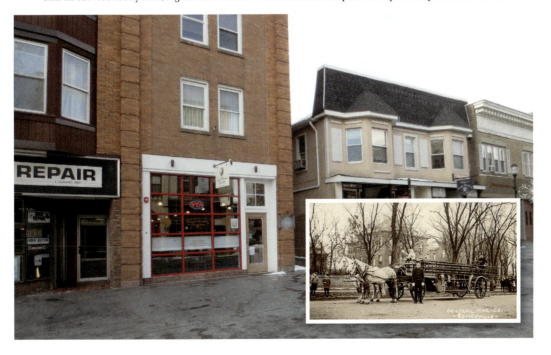

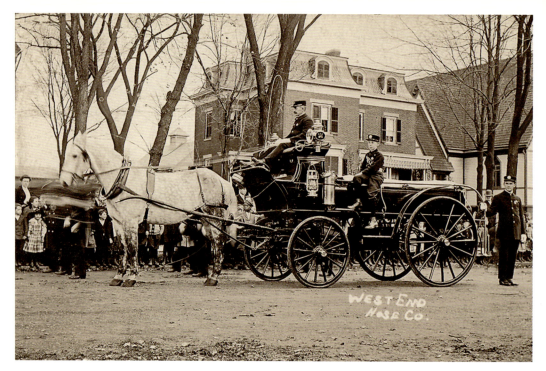

WEST END HOSE COMPANY NO. 3: West End Hose was organized in 1888 for better fire protection on the west side of town. In 1899, the West Ends bought a rubber-tired hose wagon, pulled by Mackey, the first horse in the department. After eight years of faithful service, his place was taken by Harry. The first motor apparatus in the department was bought in 1916.

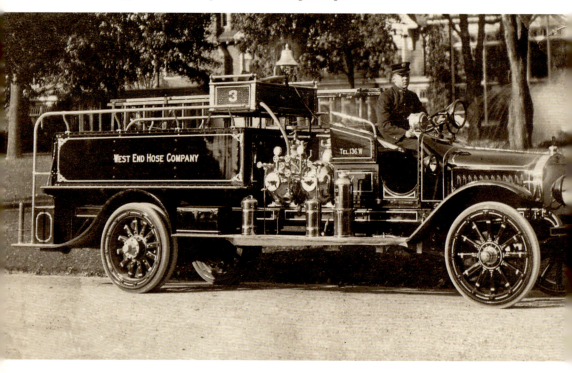

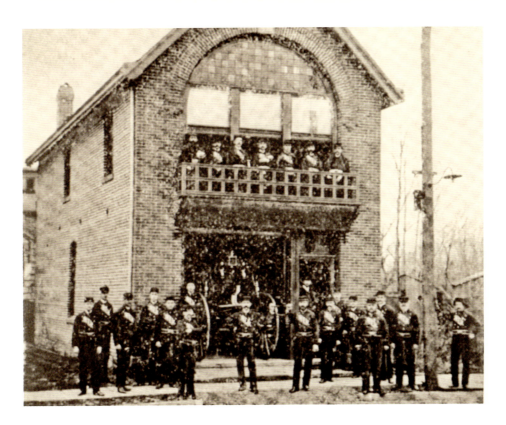

WEST END ENGINE HOUSE/ SOMERVILLE FIRE MUSEUM:
With the arrival of the first diesel-powered engine, a 1250-gallon-per-minute Hahn pumper, the West Ends moved from Doughty Avenue to their present location on High Street. The Doughty Avenue station is now the Fire Museum and is maintained by the Exempt Fireman's Association. It is open on most Saturday mornings, 10-12. The historic steam pumper (inset) is the centerpiece of the museum.

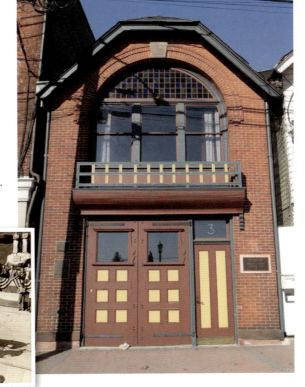

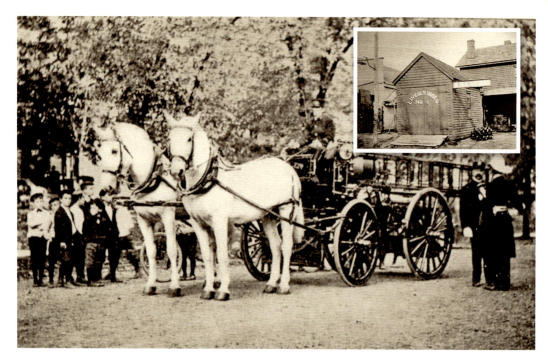

LINCOLN HOSE COMPANY NO. 4: Lincoln Hose was started in 1891 by men from the Engine Company Cadets. A small hose pumper equipped with 500 feet of hose was housed in a shed behind Layton's blacksmith shop (inset). Soon they built a three-story structure on Warren Street, which was used until completion of what is now the Lincoln Hose Firehouse. The old building (lower inset) was sold to the A. P. Cooper Lodge in 1972 and demolished in 2015. Two teams pulled the apparatus. Maud and Grace served from 1901 until 1910, followed by Duke and Barron, who pulled the wagon until it was motorized.

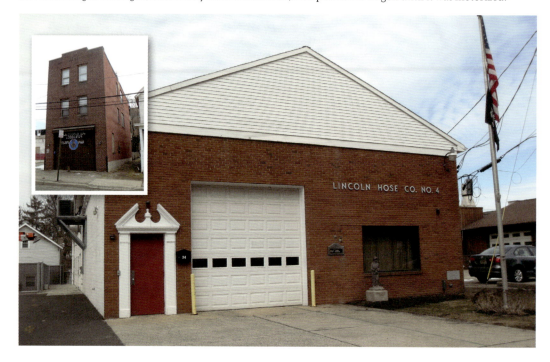

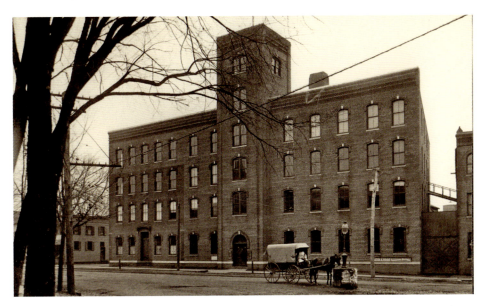

WOOLEN MILL/GRANETZ BUILDING: The Somerville Woolen Mill, a three-story brick building at West Main and Doughty, employed hundreds of workers at the turn of the century. The mill was unique in that it carried the wool from raw fleece to finished overcoat and had a brisk mail-order business in clothing. Owner James Brown's success depended on one factor: protective tariffs that kept foreign manufacturers from underselling his products. New tariff laws enacted in 1904 spelled the end for the mill, which closed in 1907. During World War I, the Calco Chemical Company got its start here, later becoming a branch of American Cyanamid, with a huge industrial complex in Bridgewater. In the older view, a horse is drinking from the town well, one side for beasts and one for people.

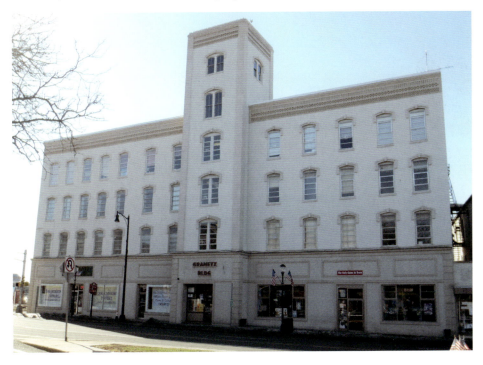

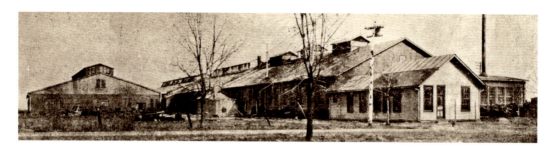

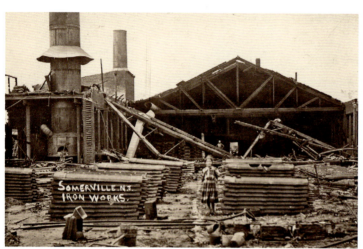

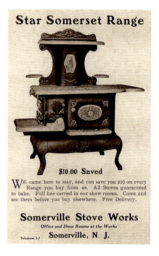

SOMERVILLE IRON WORKS AND CARBON STOVE WORKS: The Somerville Iron Works on James Street was owned by L. Lissberger & Co. of New York City. Employing over 200 men, the company produced soil pipe and fittings, letter presses, and field and lawn mowers. The Carbon Stove and Range Company, adjacent to the iron works, sold Somerville gas and coal stoves and shipped them throughout the world. In 1909 a fire destroyed both businesses.

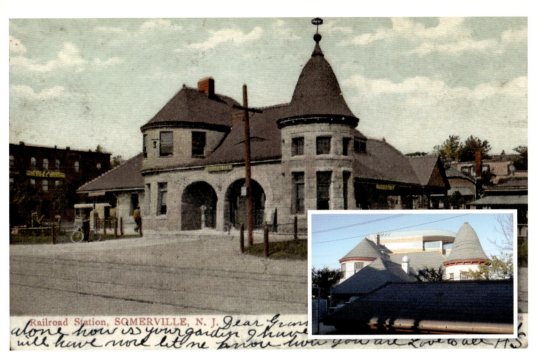

RAILROAD STATION: The railroad arrived in 1841 from Elizabethtown. In 1852 the Jersey Central built a new station, but it burned in 1867. A temporary station served until this stone structure opened in 1890. Designed in the Romanesque Revival style, it is made of sandstone to reflect the impressive buildings of the nearby estate of James B. Duke. The borough bought the station for commercial use in 1971. In 2011 New Jersey Transit completed a new train station, whose covered walkway partially blocks the view of the old stone structure from trackside (inset).

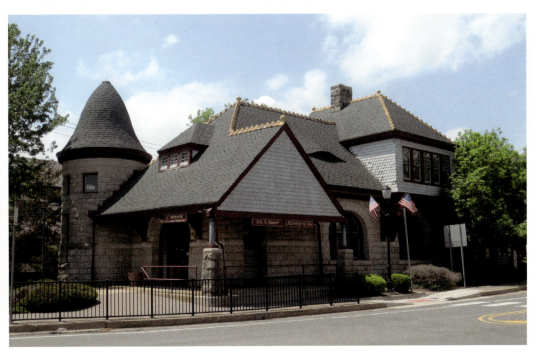

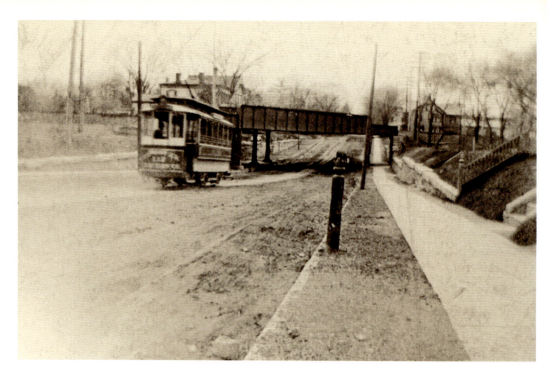

TROLLEY: The Public Service trolley ran between Plainfield and Raritan, and, with a change in Bound Brook, to New Brunswick. Before the construction of the school on Finderne Avenue, students from that part of Bridgewater took the trolley through Somerville to attend class in Raritan. Here the trolley passes under the railroad overpass on Somerset Street, in front of the Wallace House. The Senior Citizens Housing can be seen beyond the overpass.

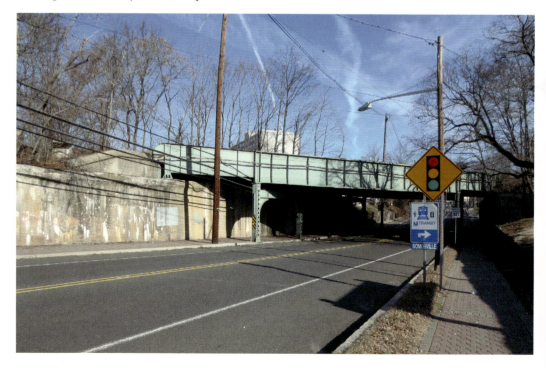

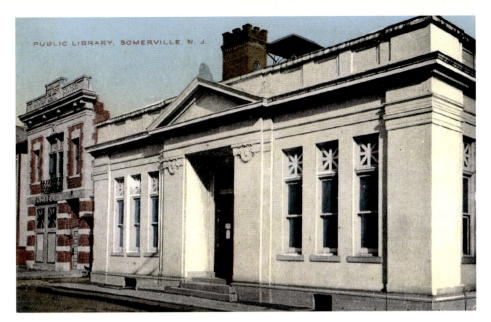

LIBRARY: Somerville's first library lasted only about twenty years (1807–1829). For the next forty years there was no library, but finally in 1871, the People's Reading Room and Library opened. Shares were sold for $2 and members paid annual dues of $1. Still this was not enough to keep it going. To raise money, the library invited Susan B. Anthony to take part in a fundraising lecture series. But when the series concluded, the net proceeds were $14.05. The dues were raised to $2 per year and by 1880 the library was doing much better. In 1902 the library moved to this Neoclassical building at 12 Maple Street and remained there until 1928.

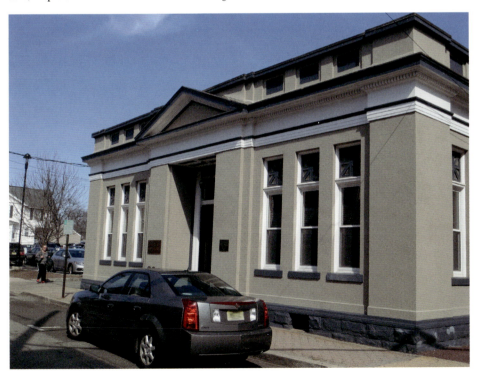

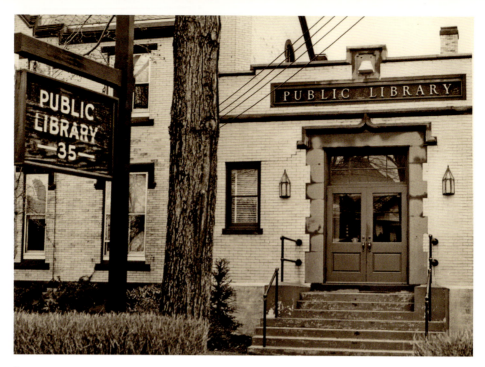

LIBRARY: In 1928 the library moved to the Schwed Mansion on the southwest corner of North Bridge and High streets, where the borough hall was housed. Thirty years later, in 1958, the Elks left their home in the Robert Mansion (now Borough Hall) and sold the building to the borough. The town offices then moved into the mansion and the library occupied the addition that once held the Elks ballroom. In 2011 the Somerville Public Library joined the Somerset County Library System.

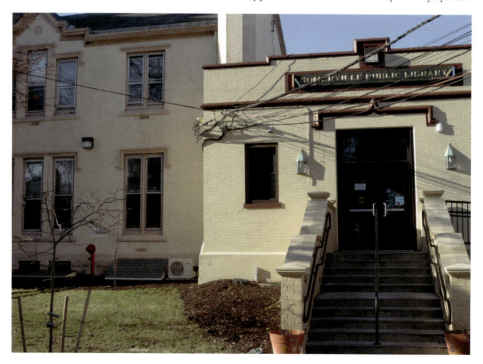

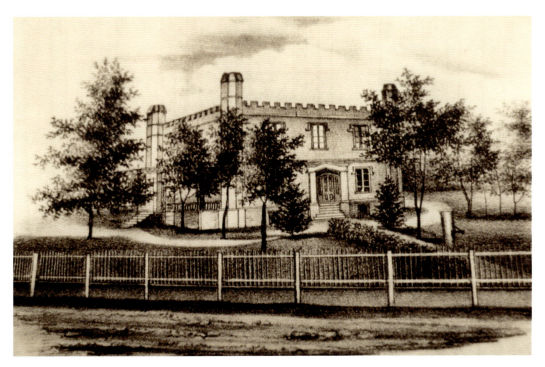

CAMMAN HOME/DOUGHTY HOME: Built in the 1840s, the mansion of Albert Camman, a prominent businessman, was the first home on this site. This Gothic showplace had the first indoor plumbing in town. In 1868 he sold it to Eugene Doughty, who lived there until 1886. Doughty sold it to Daniel Robert, who knocked down the house and built a new one, a copy of the celebrated Henry Harral house in Bridgeport, Connecticut.

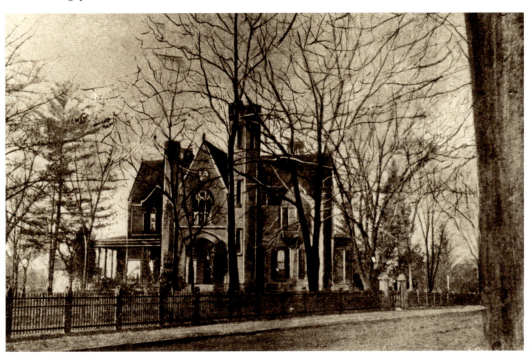

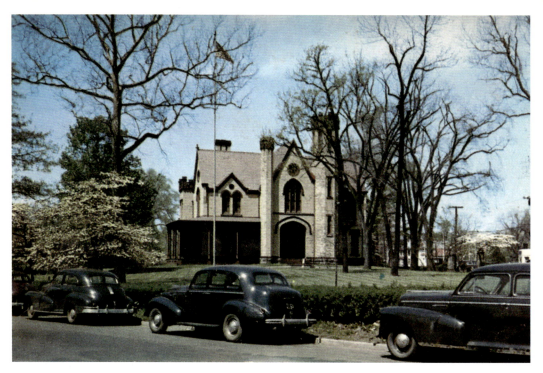

ROBERT MANSION/BOROUGH HALL: Daniel Robert lived here until his death in 1908. When his widow died in 1923, the Somerville Elks purchased the property for use as their lodge. In 1939 the Elks added the ballroom for larger functions. This addition is now home to the Somerville Public Library, and the main part of the home houses the borough offices.

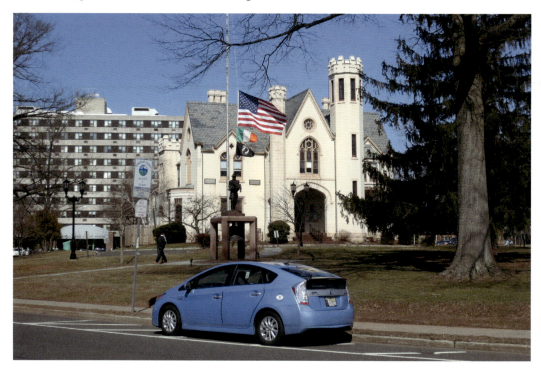

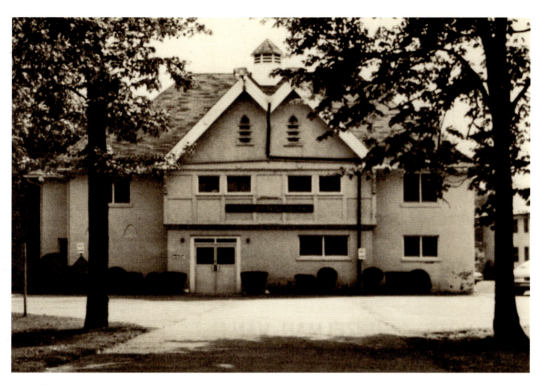

POLICE STATION: The carriage House of the Robert Mansion was the headquarters of the police department from 1939 to 1978, when it was demolished to make way for the Somerville Senior Citizens Housing, Inc. In 2015 the police department is located on South Bridge Street, behind the bank.

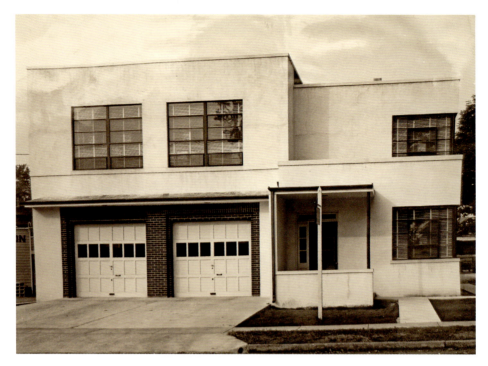

RESCUE SQUAD: In November 1928 Somerville became the first inland town in the state to organize a first aid and rescue squad. Conceived by fire chief Joseph Allgair, the squad existed for over two years with no truck of its own. Finally in April 1931, the squad purchased a truck as its first apparatus. During this time, vehicles parked at the Hoagland garage on Grove Street. The current headquarters on Park Avenue was dedicated in 1949.

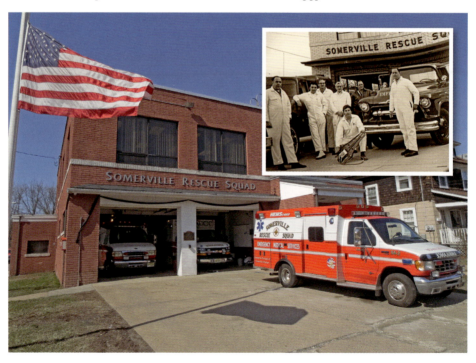

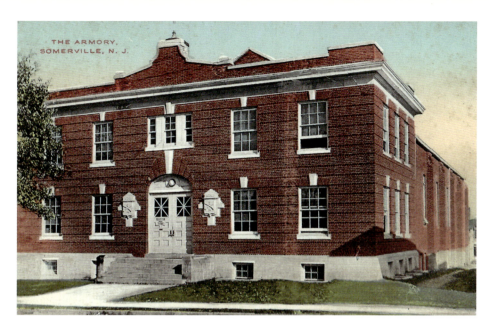

ARMORY: This was the home of Company H, of the Third Regiment, N.G.N.J., organized in 1888, with 53 men, with G. S. Cook as captain. In 1890 it ranked as the best in the Regiment for discipline, efficiency, and marksmanship. The Armory was located here from 1915 until it was taken down in 1999, several years after the county administration building was constructed. Some of its bricks have been used in the Veterans Plaza that now graces the site. The plaza's circular design features flags from each of the five branches of the armed services, as well as space for public ceremonies. There are benches for visitors who want to sit in quiet reflection.

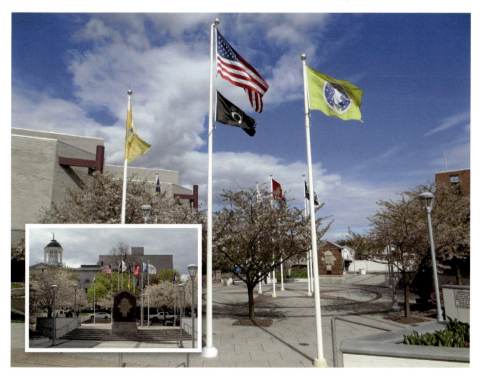

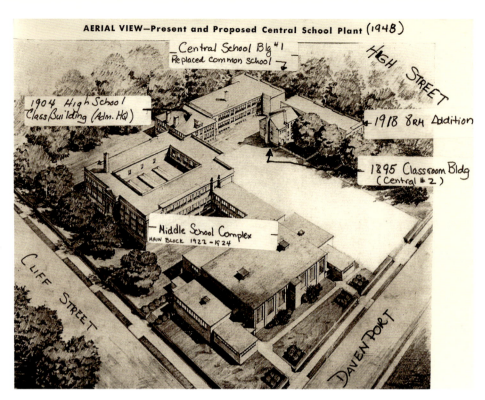

CENTRAL SCHOOL: One of Somerville's earliest public schools was a 12-room brick structure on High Street. In 1897 a second building was constructed next to the first. In 1904 an addition was built for Building No. 1; it housed the high school and later became the administrative offices. In 2009 both of those buildings were demolished in order to provide space for a playground and parking.

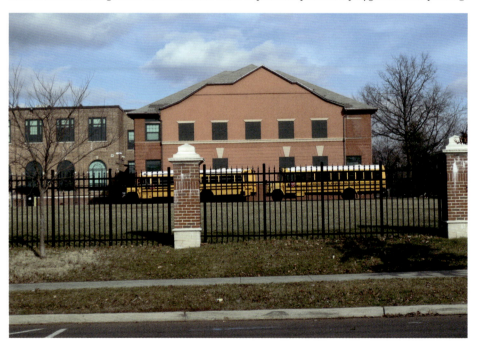

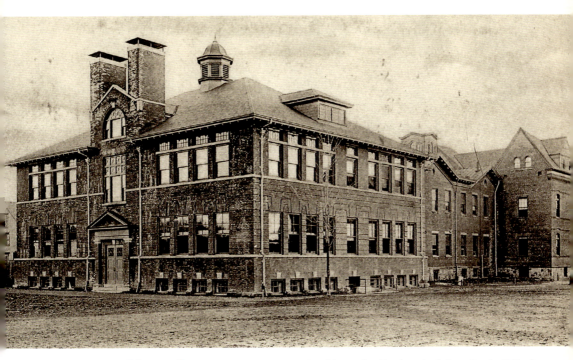

HIGH SCHOOL/MIDDLE SCHOOL: In 1922 a high school (now the district administration building) was completed on Cliff Street. When the gymnasium was added in 1949, the little frame schoolhouse was demolished.

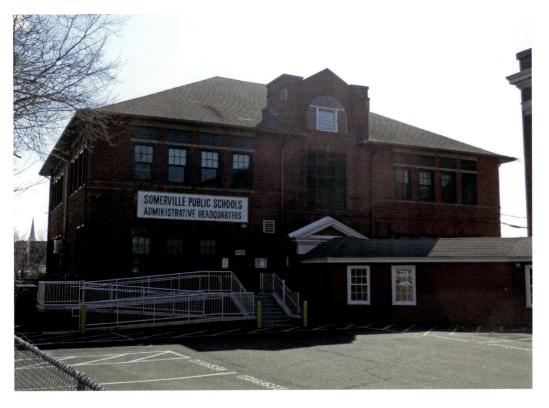

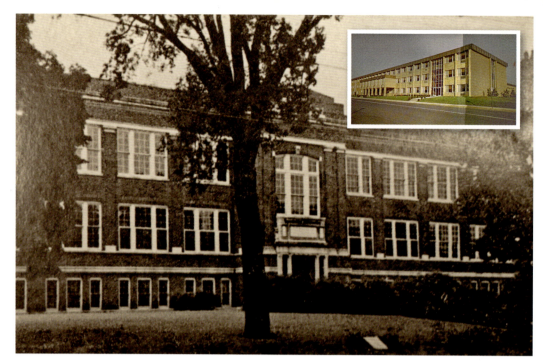

HIGH SCHOOLS: The second high school (above) is thought to be the first place in which Paul Robeson appeared on stage. In 1970, when the current high school was built on Davenport Street, the old high school on Cliff Street became the middle school.

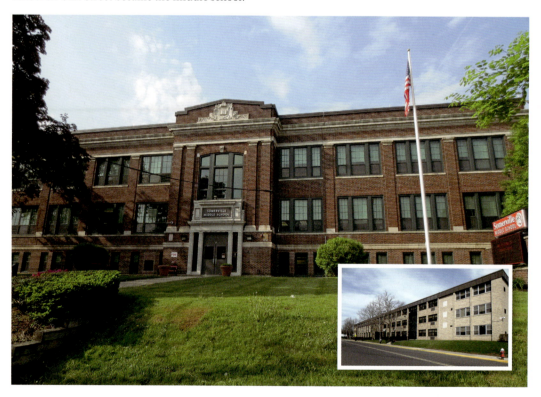

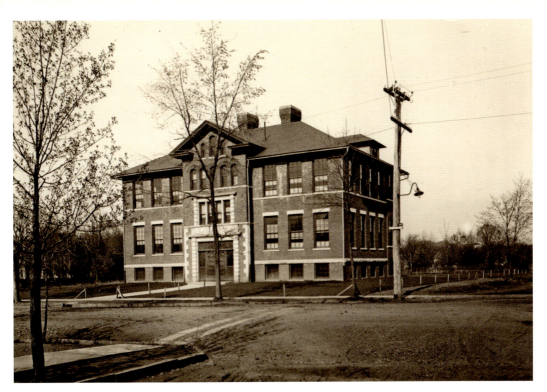

LAFAYETTE SCHOOL: As the population grew on the east end of town, Lafayette School was built in 1908 on North Gaston Avenue. Today the building is used as commercial office space.

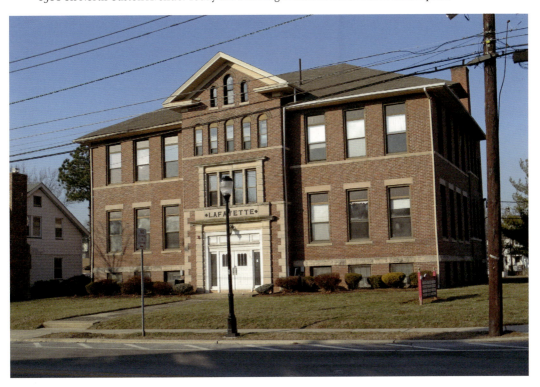

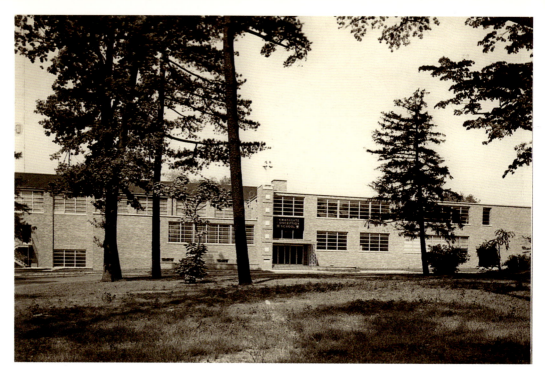

IMMACULATE CONCEPTION GRAMMAR SCHOOL: Father Eugene Kelly established the grammar school in 1957, asking for five Sisters to staff the school, with two more to be added each year until the total of seventeen was reached. The school began with 216 students in grades one to four. Each year another grade was added, so that by 1961 there were 744 students in eight grades.

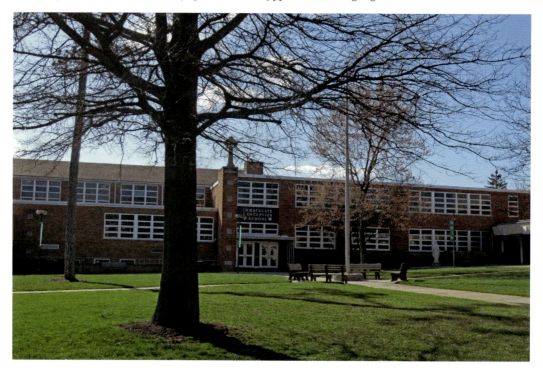

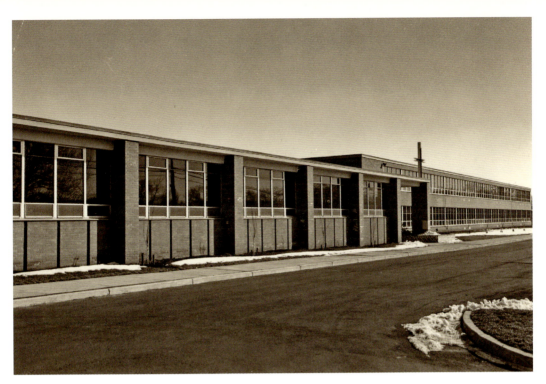

IMMACULATA HIGH SCHOOL: On May 20, 1962, ground was broken for the first parochial high school in Somerset County. Previously, local students attended St. Peter's in New Brunswick. The first high school classes were held in the grammar school, with Immaculata opening its doors in September 1963.

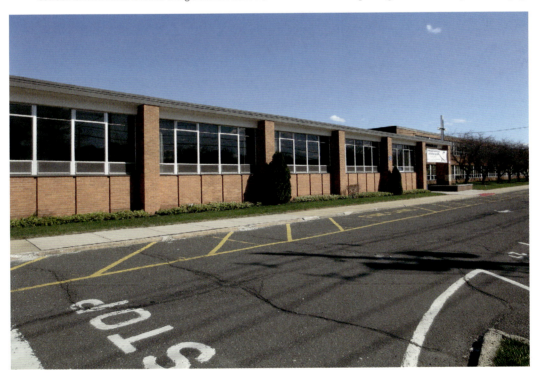

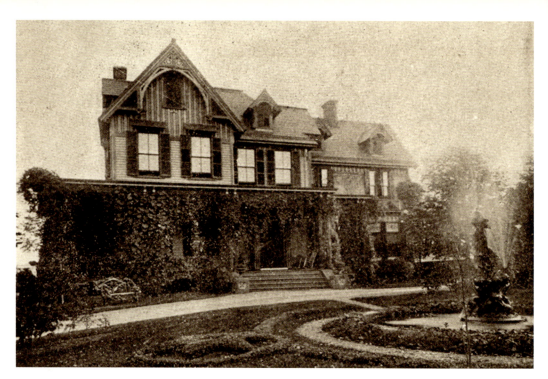

ADOLPH MACK HOME: This beautiful home on Somerset Street was the residence of Adolph Mack, one of the partners who owned and operated the Raritan Woolen Mill. The home, which stood on the corner of what is now Somerset Street and Route 206, was later used at the State Police barracks. Later it was torn down to make way for an A & P supermarket; now Walgreen's occupies that corner.

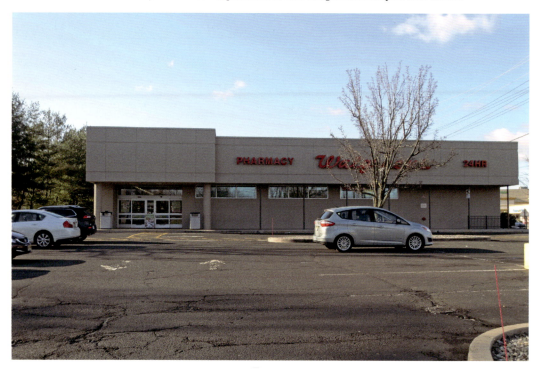

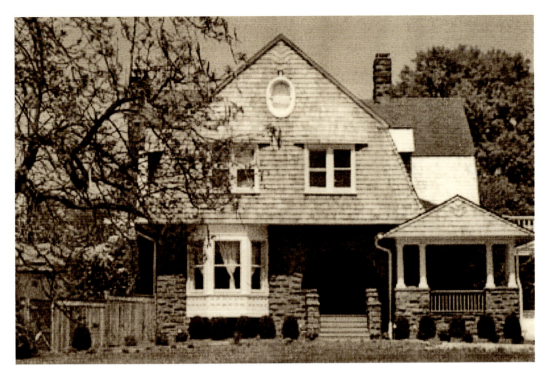

ALEX MACK HOME: SUMMIT: Originally, this block on Summit, west of Middaugh, contained only two homes. Both were built by the Mack brothers whose parents owned the Raritan Woolen Mill: one in shingled gambrel and the other in a neoclassical vernacular style. The houses were designed by Frank V. Bodine, the same architect who did the Somerville Railroad Station.

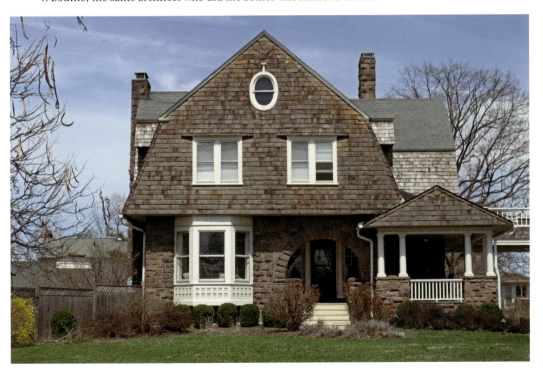

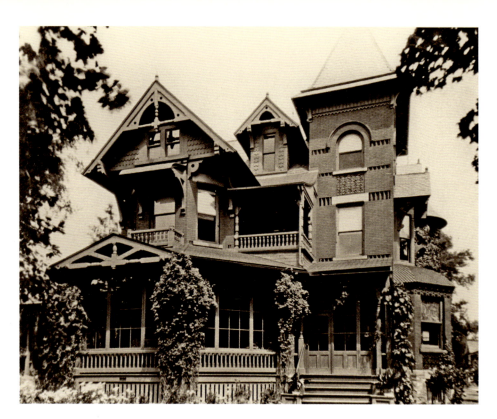

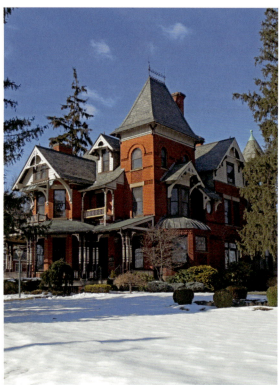

228 ALTAMONT PLACE: Constructed in 1880, this three-story High Victorian Eclectic house was the home of James Harper Smith, the longtime superintendent of the Raritan Woolen Mills. Although the architect is unknown, additions were designed by Frank Bodine. Smith engaged the renowned architect Horace Trumbauer to design his front room as a library. Trumbauer is known for his work in Newport and at Harvard. The house is in private ownership and has been completely restored. It has many Victorian details: Châteauesque towers, Roman arched windows, Queen Anne porch columns, stretcher bond brick, iron crestings on the roof, stained glass, and beautiful fretwork. The home is on the State and National Registers of Historic Places.

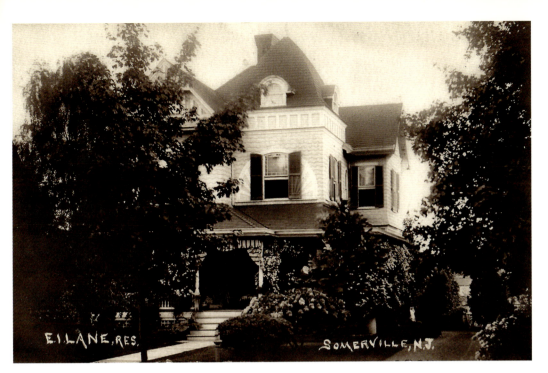

237 ALTAMONT: E. I. Lane was the owner of this lovely home at 237 Altamont. The property was also owned by J. Harper Smith and used as a residence for one of his executives at the Raritan Woolen Mill. The current owners lovingly restored this Queen Anne and did extensive research into the colorful "Painted Lady" trend of the 1980s. Only three colors were used here. Note the rich detail of the carpenter's craftsmanship with the turret finial and sunburst gables.

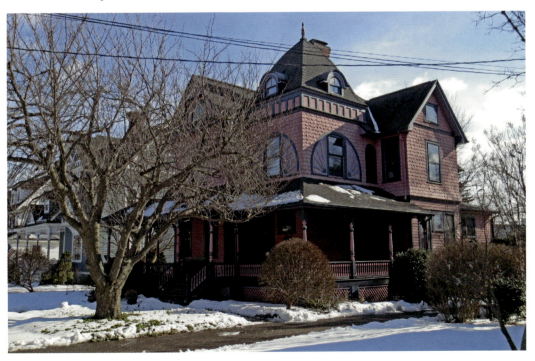

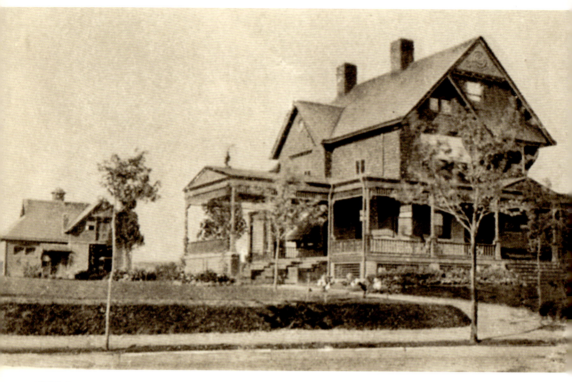

240 ALTAMONT: Captain G. S. Cook lived here at 240 Altamont Place. This Queen Anne-style home dates to 1888 and is distinguished by its interesting gable-within-a-gable and wide porte cochere.

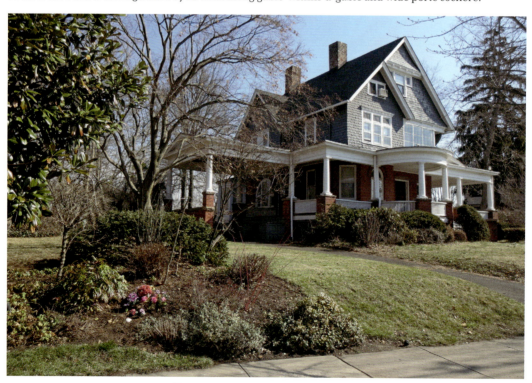

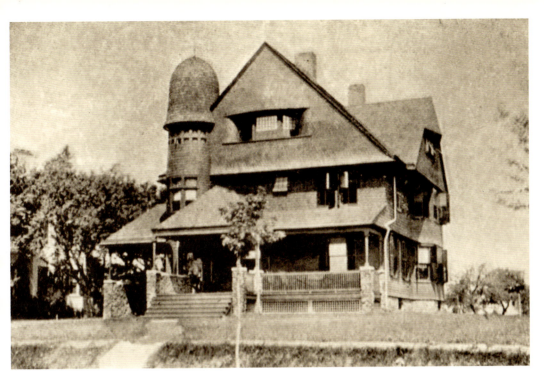

246 ALTAMONT PLACE: This large Victorian has six varieties of shingles that provide visual interest and flowing lines. The large capped tower, reminiscent of an English bobby's hat, is delineated by two bands of small square windows. The home's porte cochere is built up in stone cobbles. Edwin Scott, Esq. and later Judge Clarence E. Case and his family lived here. The Kotalic family moved here in 1963.

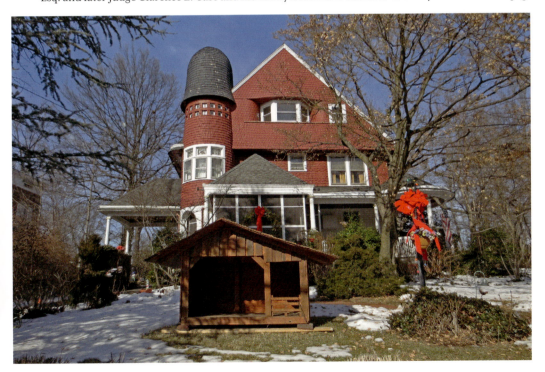

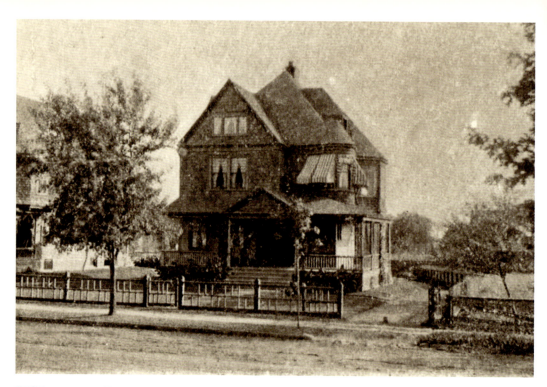

249 Altamont Place: Horace Trumbauer's Victorian style is seen in the grilled windows, double entrance doors, chimney cap, and stained glass. This house is a smaller version of a home built in 1891 in Haddonfield, NJ. Emphasis is provided by the round, second-story bay.

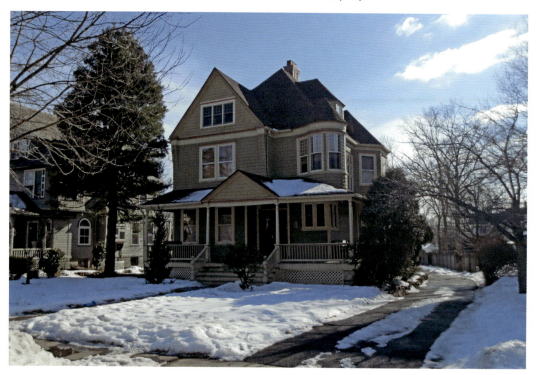

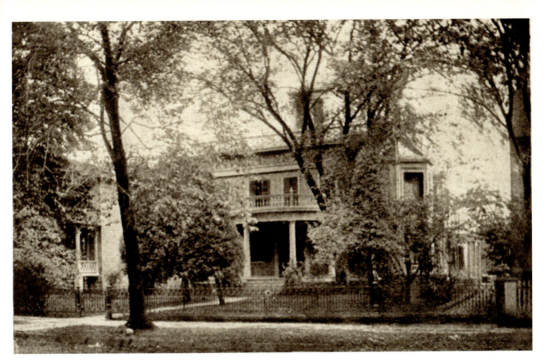

LINDSLEY HOME: This imposing Greek Revival at 10 West End Avenue was the residence of Miss Clara Lindsley. Miss Lindsley was involved in the social and cultural activities of Somerville for many years, but the library was her special favorite. On taking over as treasurer, she set out to collect current and back dues, and new members as well. She achieved this success by personally calling on all delinquent members and nonmembers as well, a one-woman door-to-door campaign. Her house became the Speer-Van Arsdale Funeral Home and later the Somerville Funeral Home.

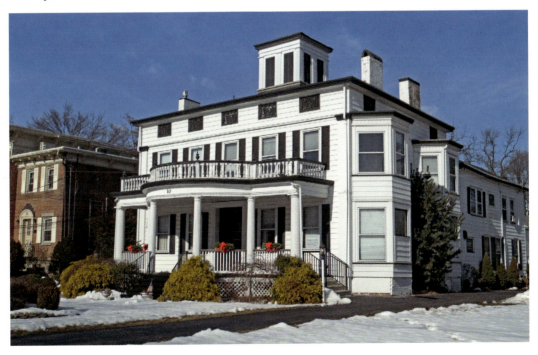

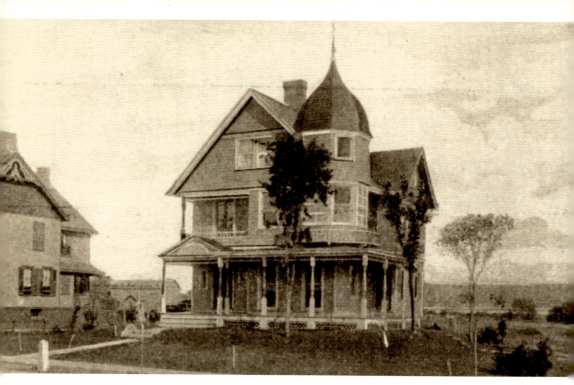

Yawger Home: G. A. Yawger, Esq. lived on Cliff Street at the intersection of Doughty. According to the 1899 city directory, Gilbert A. Yawger & Sons owned a marble works at 120 West Main. Essex A. Yawger was listed as a granite cutter in the 1888 directory and lived on Grove near Cliff.

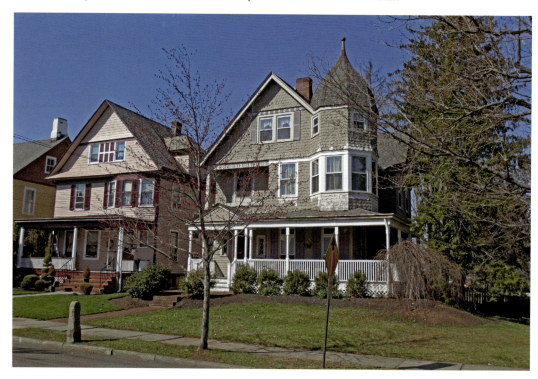

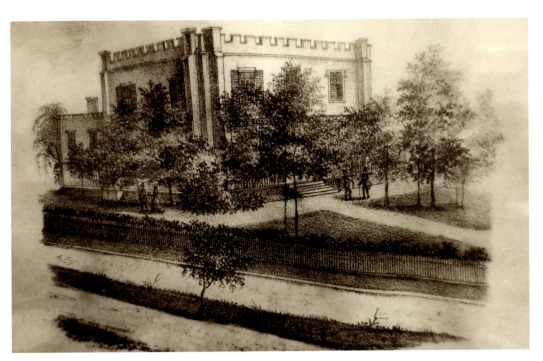

198 High Street: On the northeast corner of High and Mountain, this home was built *c.* 1851 in the Georgian style by D. Noey and later occupied by A. D. Hope. It was remodeled in the Victorian style by Joseph Ballantine in 1871. A later owner, Justice Clarence E. Case, removed the Italianate features and restored the home closer to its original design. The 1850s version featured a castellated roofline. The restoration features a symmetrical roof trim, giving the building neoclassical, rather than Gothic lines. The large beech tree on the front lawn bears witness to generations of carved names.

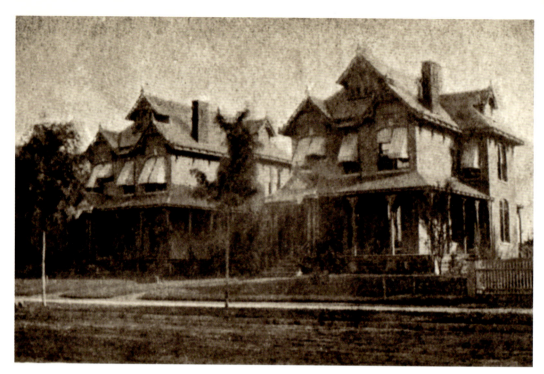

TEN EYCK TWIN HOMES: In the 1888 City Directory, a John V. D. Ten Eyck is listed as living on "High near Washington." (Washington is now Davenport Street.) Also living there was Rebecca, widow of Frederick Ten Eyck. In the 1899 City Directory, E(lizabeth) S. Ten Eyck is listed as living at 128 West High. Although changes have been made over the years, it is apparent that they were built as twins.

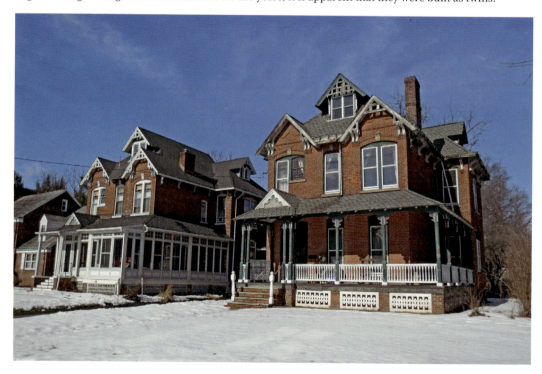

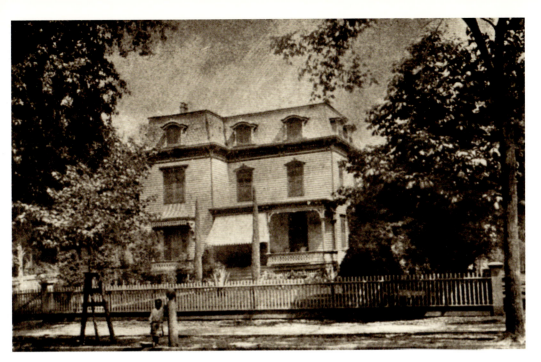

POTTER HOME: This three-story home of William S. Potter, Esq., features a mansard roof. In 2015 the Simon Law Group occupied the house.

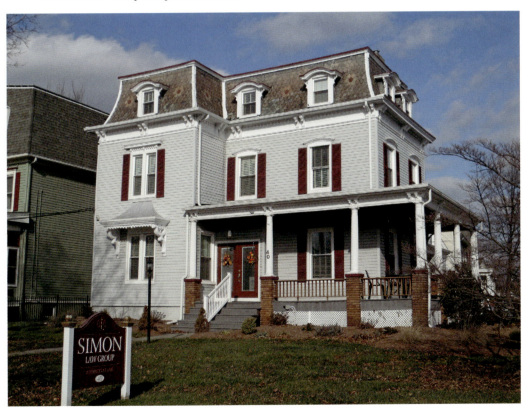

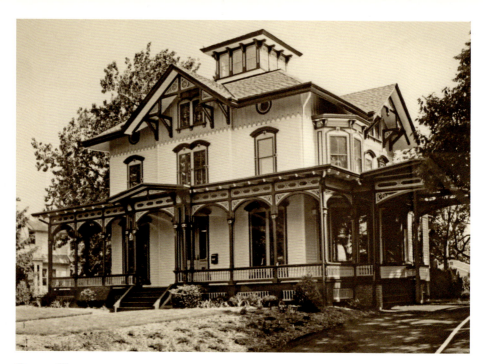

DAKIN HOUSE: This Victorian home was built by William H. Dakin between 1877 and 1880. Located at the northwest corner of North Bridge and Cliff, it eventually came into the hands of the Lefevere family, who owned it for the longest period. It features lots of gingerbread, French windows, and parquet floors. The room in the cupola is said to be the 2nd highest point in town, after the courthouse dome. Restored by Leonard Knauer in 1984, the house has 111 steps and 91 windows. It is on the site of Hangman's Hill, where hangings are said to have taken place in the early days.

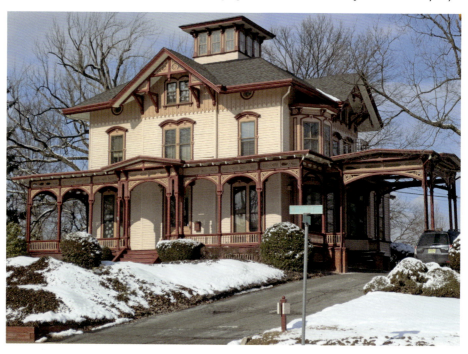

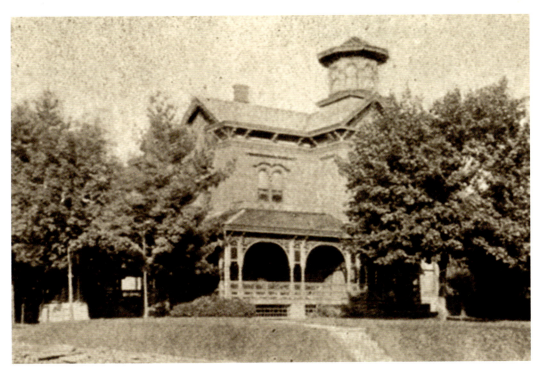

C. Stewart Hoffman Home: Built by C. Stewart Hoffman, this home was later the residence of Horatio M. Adams (1853–1956), founder of the Adams Chicle Company. Mr. Adams, known as the "gum magnate," received a patent for chewing gum in 1872. He moved to 3 East Cliff Street in 1934 and in 1953 was the town's oldest resident. As of 2015, the site of this home was still empty.

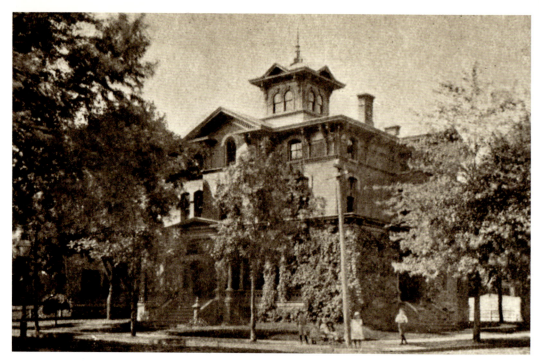

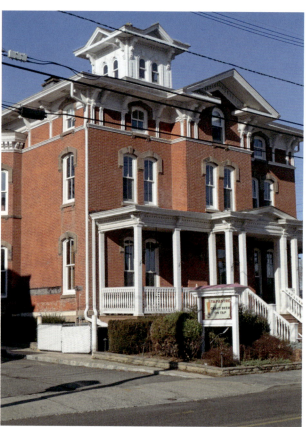

41 North Bridge Street:
Built by John Schomp, this building at the corner of North Bridge and High streets is often referred to as the Schwed Mansion. At one time it housed the Somerville Borough offices, the library, and the police station. When the upstairs housed a restaurant, diners could enjoy a meal while seated on the lovely wraparound porch. On the north side, out of sight, is the entrance to Tapastre, a restaurant in the lower level of the building.

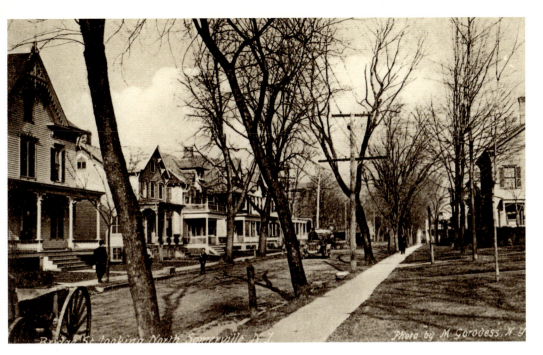

BRIDGE STREET, 1910: Looking north from Main Street, the house in the foreground is still recognizable, with its distinctive decorative trusses in the gable. The homes on the east side of the street are gone, replaced by the county building.

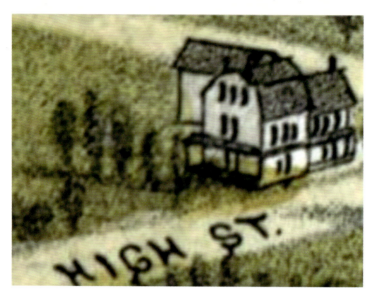

221 East High: This property purchased in 1831 from John Howell in East Somerville was later owned by Samuel C. Blackwell and his wife Antoinette Brown Blackwell, who had bought it in 1871. The Blackwells moved in, divided the surrounding 81 acres into separate lots, and built houses in this neighborhood. Antoinette Blackwell holds the distinction of being the first American woman ordained as a Protestant minister. She was very involved in the struggle for women's rights and was most likely the person who invited Susan B. Anthony to appear in Somerville. In 1893 Albert A. Lance purchased the property and created an all-seasons resort for traveling businessmen and their families. Renaming it "The Deforest House," Lance remodeled the house as a hotel for 40 guests and a casino, but went bankrupt in 1908. By 1930 Henry Gulko had converted the house into an apartment building, as it remains today. The map view is a close-up from the 1882 panoramic map of Somerville. When placed side-by-side with a current view of the house, some similarities are evident, most notably the wrap-around veranda.

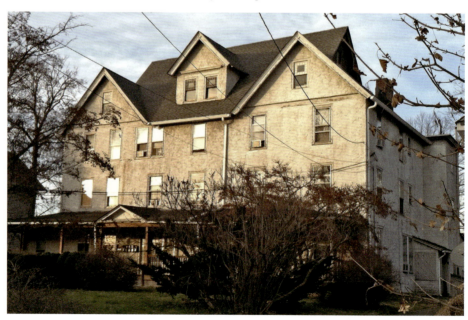

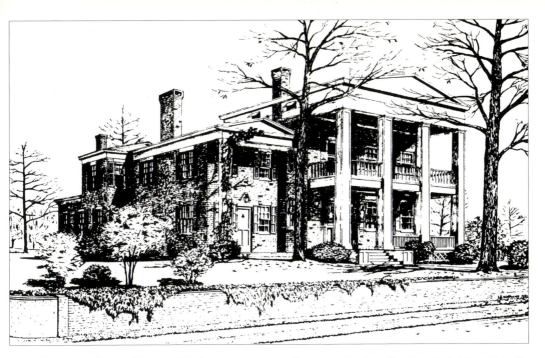

SAMUEL MILLER HOUSE: This home is an outstanding example of the Greek Revival style. Originally the side wing on the left was the kitchen, so putting the well there in the portico was a great convenience. The brick walls are laid in the Flemish bond style, in which the long and short sides appear alternately. Some of the wood beams used in construction were cut from trees that grew on the property, and the bricks were fired locally. At one time this magnificent house was cut up into apartments and sadly neglected. Fortunately, Justice Clarence Case saw it for what it really was, bought it, and wonderfully restored it into the showplace it is today.

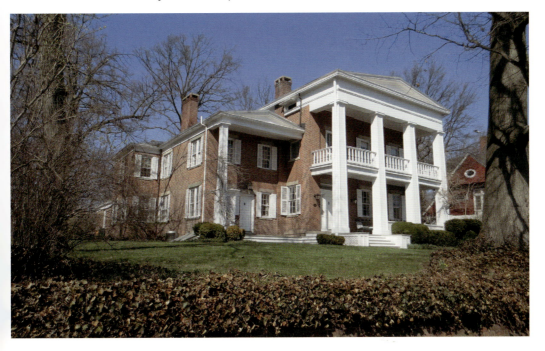

Acknowledgements

The authors wish to thank the Somerville Public Library for the use of its large collection of historic views of the borough. Thanks also to Jessie Havens, whose "Hindsight" columns provided the basis for some of the captions. In addition, many thanks to David Beales at the Somerville Public Library for his photographic genius.

Additional sources: *Remembering Somerville, New Jersey,* Jessie Havens, 2008; *Historic Somerville, New Jersey: Pillars of the Community from George to Ruth,* Jessie Havens, 2010; *The History of Immaculate Conception Parish, 1883–2008* by Carl Ganz, Jr., 2008; *History of the Jews of Somerville and Environs, 1864–2008,* by Alvin P. Levine . . . and others; "Second Story Somerville" and "Historical Walking Tour of Somerville, New Jersey" walking tour brochures; "The Story of Somerville's Borough Hall and Library"; Rob Ambrose, for his extensive research on the Blackwell home.

Thanks also to:
The Somerville Historic Advisory Committee; Gregg Buttermore; James Kurzenberger, the Wallace House State Historic Site; Marge Sullivan; Venise Fredericks and Joseph Troegner, Somerset Hospital; Ed Malberg, Temple Beth-El; Tammy Hammer and Janet Stafford of the Methodist Church; Terry Kuboski, Carol Januse, and Carl Ganz of the Immaculate Conception Parish; Susan Tiner, Sue Capetta, and the Rev. Gerald McLynn, Emmanuel Reformed Church; Karen Meulenberg, the Unitarian Universalist Church; Pastor Chelsea Miller, Ellen Parker, Charles German, and Laura Meerovich, Good Shepherd Lutheran Church; Father Ron Pollock and Lillie Hardingham, St. John's Episcopal Church; Pastor and Mrs. Reggie Hall, St. Paul Baptist Church; Pastor Loreno Flemmings and Jennifer Paternoster, the First Baptist Church; Pastor Sidney J. Webster, Shiloh Pentecostal Church; Jane Huck, United Reformed Church; Richard O'Neill, Somerville Fire Department; Roy Gunzelman, Somerville Rescue Squad; Tim Purnell and Joan Thorne, Somerville School District; June Ambs, Somerville High School; Leonard Knauer; Doris Loughlin; Dottie Kotalic; Angela Adams, Charles Kalina, and friends at the Phoenix Café; Herb Hall of Villetv; the staff at Alfonso's; Rita Jordan; Judy Beckwith; Gina Danielsen, Edison Research; and Linda Van Zandt.